Praise for *At Freddie's* and Penelope Fitzgerald

"Where some writers like to build effects slowly, Fitzgerald prefers a quicksilver economy. Vivid . . . elegant . . . astonishing."
— MICHAEL DIRDA, *Washington Post Book World*

"The wit is crisp and dry, scenes and characters are deftly skewered. Whether you view the theatre as a noble passion or a wasting disease, you are equally certain to be regaled."
— *Guardian*

"[Her] dry, shrewd, sympathetic, and sharply economical books are almost disreputably enjoyable . . . Fugitive scraps of insight and information — like single brushstrokes of vivid and true colors — convey much more reality than any amount of impasto description and research. In Mrs. Fitzgerald's novels, you can breathe the air and taste the water."
— MICHAEL HOFMAN, *New York Times Book Review*

"Enjoy the knowingness of the awful children, the weary fumblings of the professional actors, the constant witticisms at the expense of pretentious directors. An enjoyable, sharp novel . . . a delicious refreshment." — MARGARET FORSTER

"The finest British writer alive."
— RICHARD EDER, *Los Angeles Times / Newsday*

Books by Penelope Fitzgerald

Fiction

THE GOLDEN CHILD

THE BOOKSHOP

OFFSHORE

HUMAN VOICES

AT FREDDIE'S

INNOCENCE

THE BEGINNING OF SPRING

THE GATE OF ANGELS

THE BLUE FLOWER

THE MEANS OF ESCAPE

Nonfiction

EDWARD BURNE-JONES

THE KNOX BROTHERS

CHARLOTTE MEW AND HER FRIENDS

A HOUSE OF AIR: SELECTED WRITINGS

SO I HAVE THOUGHT OF YOU:
THE LETTERS OF PENELOPE FITZGERALD

Penelope Fitzgerald

At Freddie's

Introduction by Simon Callow

MARINER BOOKS
HOUGHTON MIFFLIN HARCOURT
BOSTON NEW YORK

Second Mariner Books edition 2014

First published in Great Britain in 1982 by William Collins Sons and Co., Ltd.

Reprinted by arrangement with HarperCollins Publishers

www.hmhco.com

Library of Congress Cataloging-in-Publication Data is available.
ISBN 978-0-544-35948-2 (pbk)

Printed in the United States of America
DOC 10 9 8 7 6 5 4 3 2 1

At Freddie's

Introduction

I first encountered *At Freddie's* — and its author — in curious, rather Penelopean (or should that be Fitzgeraldian?) circumstances. Sometime in 1987, I received a letter from a certain Jerry Epstein, hitherto unknown to me, telling me to get in touch with him, when I would hear something to my advantage. Jerry was short, bearded and oddly shapeless, like a lump of clay abandoned by the sculptor before he had completed his task, but enthusiasm and big laughter exploded out of him; he made everything seem not only possible, but imminent. It turned out that he had directed a well-regarded film of Elmer Rice's 1923 play *The Adding Machine*, but his great claim to fame was that he had been Charlie Chaplin's last producer. He had acquired the rights to *At Freddie's*, and he believed that I (who had never written or directed a film before) was the ideal — the only — person to write and direct it. I walked away from the meeting thinking that Orson Welles's mantle of actor-director-writer was about to descend on me, and set about reading the book, and everything else by its author that I could get my hands on.

Is there any pleasure greater than discovering a writer of whose existence you have been unaware, but who turns out to be absolutely on your wavelength? It's like making a new friend. No, it *is* making a new friend, and Penelope Fitzgerald was immediately my new best friend. In particular, *At Freddie's* (1982) might have been written for me personally, I felt. It distilled an aspect of the theatre for which I have always had a special affection: the shabby, peripheral hinterland of the stage, away from the great triumphs and the brightest lights, obliquely touched by association with that glamorous world, its denizens doing their plucky best to impersonate their

famous originals. It is an essential part of the theatre's ecology, and Miss Fitzgerald had miraculously captured the feel of it in her gallery of B-list theatrical characters: quirky, touching, their hopes and dreams all doomed but all nonetheless lit up by their devotion to the idea of the theatre. As in many of her novels that I had just gobbled up, in *At Freddie's* Miss Fitzgerald purveyed a most unusual quality, an admiring affection for the peccadilloes and eccentricities of the people she had created which amounted to a sort of understated, wry romanticism. I could scarcely wait to turn it into a film which, though scarcely aspiring to blockbuster status, might illuminate a unique corner of human experience within a deliciously shabby theatrical frame, like a peeling proscenium arch. I duly knocked off a treatment which sought to recreate that world before the great juggernauts of theatre – the National Theatre and the Royal Shakespeare Company – had loomed into view, in a Covent Garden, where most of the action is set, which was still a flower and vegetable market, its destiny as a tourist trap not even yet dimly glimpsed.

My collaboration with Jerry was not without its vicissitudes. They hinged on one fundamental difference: I wanted to film Fitzgerald's book in all its loving subtleties, whereas Jerry saw it as a mere starting point for a series of generic scenes, broad comic sketches and vaguely transatlantic sentiments. I could never quite understand why he had approached me to be his collaborator. Probably anyone would have done, because after each script meeting at which he would enthusiastically acclaim my every suggestion, I would laboriously write them up and despatch them to him (no laptops, then, no email). He would phone me with tears in his voice to tell me how fabulous every etched line of mine was, what a natural screenwriter, what a superbly human and insightful artist I

was. He would just have my clumsily bashed-out pages typed up into proper movie-script format and we'd be ready to go. A very authentic-seeming screenplay would duly arrive on my doormat bearing not even a vague resemblance to anything I — or indeed Penelope Fitzgerald — had written.

At some point he arranged for me to meet the admired and now increasingly popular novelist. He decided, to my considerable relief, that it would be better if we were to meet without him. For some reason we ended up in the old Palm Court of the Waldorf Hotel in Aldwych, not far, as it happens, from the purported location of the school and next door to the theatre where the novel's climactic scene is set. The Palm Court suited Penelope very well, the sedate choreography of the participants in the *thé dansant* belying what she assured me were smouldering adulterous liaisons. She was middle-aged, delicate-featured, fragrant, her attire pastel-hued and floral-patterned; her all-seeing eyes a little dreamy, almost veiled, her smile witty. There was nothing even remotely theatrical about her. She answered all my questions about the experiences that had led to the writing of the book, above all her time as an English teacher at the Italia Conti stage school, but it was very clear that — just as she had with the BBC in her exquisite earlier novel *Human Voices* — she had distilled and enriched her material to create an essence of a very quirky organisation, evoking both its absurdity and its splendour. In the case of *At Freddie's*, she had osmotically understood something of the theatre's compromised mystery, its tawdry power.

She observes with an insider's eye, though as I now dis-covered she was not an insider at all. A remarkable gift of empathy, or perhaps even of identification, informs her portrait of a now long-vanished world of dashing but feckless leading men, of gin-sodden classical actors, of theatrical garden parties,

now just part of the collective unconscious of the theatre. Absurdly pretentious directors and nauseatingly precocious child actors, on the other hand, remain with us, and no doubt always will. As will genuine talent, to which Fitzgerald pays beautiful homage in the figure of the boy genius, Jonathan Kemp. In her central character, the eponymous Freddie, she has created an archetype, a force of nature, a sort of Mother Courage of juvenile stage schools, endlessly adapting in order to survive. Fitzgerald has no sentimentality about Freddie, though she celebrates her indomitability: by the last chapter, the old baggage rises above everything and everyone, ruthless and heartless to the end. The grit that so unexpectedly characterises Fitzgerald's exquisitely wrought fictions is right at the heart of *At Freddie's*.

I offered the part of Freddie to Alec Guinness, who was tempted but finally declined on the grounds that he thought he'd done enough drag in his career. Instead, I wrote up the part of Ernest Valentine, the old actor-laddie, embroidering it with stories that Alec himself had told me about crumbling old thespians of his youth. I think he might have done it, too, but Jerry somehow never managed to raise any capital. I never knew, of course, which version of the script he had sent to potential backers — his Disney version, Hilarious!!!! and Heartbreaking!!!!, or the altogether more demure, harsher and mysterious Fitzgerald–Callow take. He only gave up on *At Freddie's* reluctantly, but he did give up, and I never found a backer who could see any commercial potential in the project.

I saw Penelope a few times during the period of gestation of the screenplay, and then, later, we had an exchange of letters over her superb novel, *The Blue Flower*, which I recorded. Writing to me after hearing the recording she thanked me for 'making it sound a much better novel than I remember having written'.

The later work was of exceptional power, complexity and resonance, but *At Freddie's* is a superb achievement, simply as a novel in its own right, and, as one of the tiny handful of great theatre novels, up there with Michael Blakemore's *Next Season*, Priestley's *Lost Empires* and Michael Redgrave's *The Mountebank's Tale*; like them, it is precise about the theatre's workings and profound about its meaning. I still long to film it.

<div style="text-align: right">

Simon Callow
2013

</div>

To Freddie

1

It must have been 1963, because the musical of *Dombey & Son* was running at the Alexandra, and it must have been the autumn, because it was surely some time in October that a performance was seriously delayed because two of the cast had slipped and hurt themselves in B dressing-room corridor, and the reason for that was that the floor appeared to be flooded with something sticky and gluti-nous. The flood had been initiated by one of the younger boys in the chorus. He had discovered a way to interfere with the mechanism of the B corridor coffee-machine so that it failed to respond to the next fifty sixpences put into it. The defect was reported, but the responsibility for it was argued between the safety manager and Catering. When the next coin was put in the machine produced, with a terrible pang, fifty-one plastic cups, and then heaved and outpoured its load of milky liquid.

At eleven years old, Mattie could not have hoped for a better result. The production manager said that he must go. These quaint tricks were for leading players only, and even then only at the end of a long run.

'This is the third bit of trouble we've had with him, we shall have to send him back.'

The casting director thought there were three weeks of his contract to run. The GLC, mercifully perhaps, only allowed children to appear in commercial productions for three months on end.

'No, not in three weeks, we're returning him at once good as new, they'll have to send us another one. Where did you get him from?'

'Freddie's.'

Both wavered. The casting director told his assistant to notify the Temple Stage School. The assistant spoke to his deputy.

'Perhaps you'd better go and see her.'

The assistant was surprised, having studied a casual style.

'Won't it do if I phone her?'

'Perhaps, if you're good at it.'

'Where will she be then?'

'Freddie? At Freddie's.'

'I'm afraid you'll have to speak a little more clearly, dear. It comes with training ... you can't have rung me up to complain about a joke, an actor's joke, nothing like them to bring a little good luck, why do you think Mr O'Toole put ice in the dressing-room showers at the Vic? That was for his Hamlet, dear, to bring good luck for his

Hamlet. I'm not sure how old O'Toole would be, Mattie will be twelve at the end of November, if you want to record his voice, by the way, you'd better do it at once, I can detect just a little roughening, just the kind of thing that frightens choirmasters, scares them out of the organ-lofts, you know. I expect the child thought it would be fun to see someone fall over . . . two of them detained in Casualties, which of them would that be, John Wilkinson and Ronald Tate, yes, they were both of them here, dear, I'll send Miss Blewett round to see them if they're laid up, she can take them a few sweets, they're fond of those . . . I suppose they'd be getting on for thirty now . . . well, dear, I've enjoyed our chat within its limits, but you must get the casting director for me now, or wait, I'll speak to the senior house manager first . . . tell him that Freddie wants a word with him.'

The senior house manager came almost at once. Having intended to say, and for some reason not said, that all this had absolutely nothing to do with him, he summoned indignation in place of self-respect and spoke of what had come to his ears and not knowing what might happen next, also of possible damage to the recovered seats, and the new carpeting which had recently been laid down in every part of the house.

'What became of the old chair covers?' Freddie interrupted. 'What of the old carpets?'

The manager said that this was a matter for his staff.

It seemed, however, that the Temple School, with its forty years of Shakespearean training, was carrying on the old traditions in a state not far from destitution, with crippled furniture, undraped windows, and floors bare to the point of indecency, and it was not to be believed that a prosperous theatre like the Alexandra would stand by and watch such things happen without giving a helping hand. The manager knew what was happening to him, even though it was for the first time, for he had heard it described by others. He was being Freddied, or, alternatively, Shakespeare would have been pleased, dear-ed, although the phrase had not passed between them. Thirty-seven minutes later he had agreed to send the old covers and carpeting round to the Temple, on indefinite loan. He felt unwell. Weakmindedness makes one feel as poorly as any other over-indulgence.

Everyone who knew the Temple School will remember the distinctive smell of Freddie's office. Not precisely disagreeable, it suggested a church vestry where old clothes hang and flowers moulder in the sink, but respect is called for just the same. It was not a place for seeing clearly. Light, in the morning, entered at an angle, through a quantity of dust. When the desk lamp was switched on at length the circle of light, although it repelled outsiders, was weak. Freddie herself, to anyone who was summoned into the room, appeared in the shadow of her armchair as a more solid

piece of darkness. Only a chance glint struck from her spectacles and the rim of great semi-precious brooches, pinned on at random. Even her extent was uncertain, since the material of her skirts and the chair seemed much the same. The covers from the Alexandra, of drab crimson with bald patches, were put on to the furniture as soon as they arrived, but made, after all, little difference. Opposite was another, much smaller, armchair, which, though Freddie kept no pets, gave the impression that a dog had just been sitting in it. Placed there, the caller had to meet Freddie's eyes, which, though not at all bright — they were of a pale boiled blue — expressed an interest so keen as to approach disbelief. The face, like the ample skirt, was creased with lines, as though both had been crumpled together at the same time. What might a good ironing not reveal?

Although Freddie usually began by saying something gracious, the caller's first instinct was that of self-preservation, or even to make sure that the door, now to the rear, could be reached in a hurry. Yet in fact no one left before they had to. The margin between alarm and fascination was soon crossed. Partly it was her voice, a croak suggestive of long suffering, which adjusted itself little by little, as though any difficulties were worthwhile, to caressing flattery. This flattery usually saved Freddie money. — I hope you don't mind the room being rather

cold, I don't notice it myself while I'm talking to you — knowing that this kind of thing could be seen through, but that in itself constituted a further flattery. Certainly she could create her own warmth, a glow like the very first effects of alcohol. As to what she wanted, no mystery was made. She wanted to get the advantage, but on the other hand human beings interested her so much that it must always be an advantage to meet another one. When she smiled there was a certain lopsidedness, the shade of a deformity, or, it could be, the aftermath of a slight stroke. Freddie never tried to conceal this — Take a good look — she advised her pupils — I'm not nearly so amusing as you're going to be when you imitate me. — But the smile itself was priceless in its benevolence, and in its amusement that benevolence could still exist. One had to smile with her, perhaps regretting it later.

Her shabbiness was a grossly unfair reproach. Her devotion to the things of the spirit was a menace. The trouble, of course, was that she never asked anything exactly for herself. Why, after all, had the Alexandra parted with so many lengths of rep and velvet? Why did the Royal Opera House, at every end-of-season auction, allow so much indulgence to bids from the Temple School? Why was Freddie represented — looking just the same, even with the same skirt and brooches — alongside of the Great Stars of All Time on the safety-curtain of the Palladium? Why, again, was Mattie allowed to go on

working in *Dombey & Son*? Only because Freddie cared so much, and so relentlessly, for the theatre, where, beyond all other worlds, love given is love returned. Insane directors, perverted columnists cold as a fish, bankrupt promoters, players incapable from drink, have all forgiven each other and been forgiven, and will be, until the last theatre goes dark, because they loved the profession. And of Freddie — making a large assumption — they said: her heart is in it.

She must have had origins. Even for Freddie there must have been some explanation. It was understood that she was born in 1890, and was a vicar's daughter. Some periods of her life were not well explained. A fading photograph on the wall showed her in the streets of Manchester, apparently raising the banner of the Suffragette Movement. But who was the male figure to her right, in a half-threatening attitude, with his foot on the pedal of a tandem bicycle? Was it then, perhaps, that she had had her stroke? A later photograph, with Freddie in breeches and puttees, was much clearer. She was hoeing turnips to make into jam for the men in the trenches. Certainly she had left her job as a Land Girl in the following year, 1917, and come to London to join the staff of the Old Vic. That meant working for the formidable Lilian Baylis, who had taken over the place five years earlier as a temperance coffee house in a disreputable quarter, and had turned it into a Shakespearean theatre for the people. Miss Baylis

declared that she was not educated and not a lady, and did only what God told her to. Her staff were warned that they would have no home life of any kind. Her audiences, broken in to the hard seats, were entirely loyal. Her theatre was so uncomfortable and so deeply loved that it was believed that the British public would never allow it to close. She was the Lady of the Vic, almost the only person of whom Freddie spoke with respect.

It was from Lilian Baylis that she had studied the craft of idealism, that is to say, how to defeat materialism by getting people to work for almost nothing. At the Vic, indeed, the lower-paid actresses often had to take men's parts, and were told that it would be good for them to put on beards and speak such lovely lines. Freddie did not copy these methods, rather she invented her own variations. In one way, however, she surpassed the Lady, who told her staff: 'Come to me in your joys and come to me in your sorrows, but not in between, because I've not time for chit-chat.' Freddie, on the other hand, was always ready to talk, and, in those days, to listen. By the end of the war she had come to know and be known by pretty well everyone in the London theatre.

In 1924 she left the Old Vic, not at all on bad terms with Miss Baylis, but with a recognition that the two of them, compressed under one roof, might provide the conditions for an explosion. With a small legacy – but who was it from? – she opened the Temple School.

A certain amount of her life, then, was accounted for. But there were conflicting elements. Her assistant, Miss Hilary Blewett, had been favoured with darker glimpses, Freddie having told her more than once that she had known the very worst of poverty. That was either in Peterborough or St Petersburg, Miss Blewett hadn't quite been able to make out which. The Bluebell was, by the way, quite capable of disbelief. Her devotion to Freddie, necessitating very long hours, was difficult to explain, even to herself. She was, perhaps, under some form of mild hypnosis.

Freddie's name was Wentworth, but she scarcely ever referred to her relations. There were no photographs of them. Her younger brother, however, who was a reputable solicitor on the south coast, had been known to call, though only once, at the Temple. Worried about his sister's finances, or what he guessed of them (not having seen her for many years), he sent her a carefully composed letter. Freddie told him that she had been too busy to read more than the first sentence.

'I imagine I am as busy as you, Frieda, and to considerably more profit.'

He was sitting awkwardly in a small armchair, not at all right for a solicitor.

'I have to conserve my energy, dear. I manage that by never doing anything that isn't strictly necessary, and above all by never reading anything I don't have to. I

knew you'd tell me what was in your letter.'

'Look, Frieda, I've been trying to think back to the time before this atmosphere of craze, I scarcely know what to call it, anyway this involvement with the theatre, began. Of course, I'm considerably younger than you are, I always have been. But I'd like to know how it was that you became so set on running this school, which I'm afraid is leaving you in a very discouraging financial position . . . I'm simply asking you to take stock of your position, Frieda.'

'Well, it was good of you to come, James, and I'm interested you should have thought it worthwhile to do so. I think it will make you feel better. Why, this very evening, when you talk things over with your wife – what is her name, by the way?'

'Cherry,' the solicitor replied.

'But that was your first wife's name.'

'I have only been married once, Frieda.'

'When you tell her that this place appeared not to have been dusted for God knows how long, and that I couldn't even find your letter, and what an old wreck I looked, and so forth, well then you'll be able to tell each other at regular intervals how good it was of you to come.'

'Cherry and I would like you to come and have dinner with us,' he persisted.

'You'd like to feel that I've *had* dinner with you,

perhaps. But I've reached a point in my life where I never go out in the evenings. You've nothing to reproach yourself with on that score.'

She remained calm, with an imposing appearance of sanity. But that wouldn't do, all the common sense was on his side, as the frayed furniture bore witness. From notes which he had made he began to read an analysis — simply a rough guess, since she hadn't seen fit to confide in him — of the school's finances at the present time; he'd just asked around and had been told that there weren't more than forty pupils, if that, and there was a dangerous dependence on *Peter Pan* and the Christmas shows for employment, with the odd musical and the few Shakespearean parts. No TV work, no film work, no modelling, the Temple didn't countenance any of them. — A luminous smile passed over Freddie's face, as though the depths stirred. — He persevered, asking how long it was since she had had the place surveyed or inspected in any way. Freddie replied that a Ministry of Education inspector was due in a few weeks' time. When the solicitor brightened she added that she hoped the Ministry wouldn't send anybody too heavy as she was doubtful about the sagging floor of the upstairs hall, and had given the children instructions never to walk straight across it, but to skirt round the edge of the boards. His sharp glance, rather like hers at that moment, told her that she was exaggerating. Probably she was trying to

amuse him. As it happened, he was quite wrong. If his ears had been a little keener he could have heard the alternate shuffling and pattering above their heads. But he was a man who kept his eye on things, rather than listening to them. He said that he was obliged to be going, for, as a busy man, a necessary condition of his being anywhere was to be on the way somewhere else. He picked up his coat and brief-case, and then, although he knew that he had brought nothing else with him, looked round, as though he were not quite sure.

'I don't like to leave you like this, Frieda.'

'You'll find me looking exactly the same next time you come.'

'That's what I'm afraid of. I don't find the idea at all reassuring.' As he continued the moves of departure, Freddie, who had never stirred from her chair, pointed to a bureau which stood sideways on, struggling for position between two larger chests of drawers.

'Help yourself out of the left hand small top drawer, James. That's where I keep the complimentary tickets, I've forgotten what's there.'

'Well, if they're going to waste . . . I've no objection to a good show . . . there's a glass of milk here which seems to have been there for some time,' he added as he opened the bureau. But he could not regain the upper hand.

'You'll find some passes for the Palladium, dear. Tell Cherry they're good for any night.'

He put them carefully away into a compartment of his notecase. As he got into his car he felt a sense of injustice at not being able to dislike his sister more, for surely she was not likeable. The smile she had given him at the last minute was probably responsible.

This method of dealing with her relative, or relatives, left Freddie at liberty to elaborate the story of her life pretty much as she wanted. She was not likely to be challenged. To take one more example: could it be true that at one time she had been on the stage herself? When she rose from her chair her bulk was supported by the unmistakable, not very graceful, walk of a dancer, the upper part of the body quite still, the feet planted flat, like a sea creature on dry land. It was startling to see her glide forward like that. She enjoyed the surprise it caused.

2

WHEN Mattie looked into the school on his way home from the Alexandra, Freddie was sitting with Miss Blewett and Unwin, the embittered accountant. Mattie poked his head round the office door, with all the bright airs of the indulged.

'Go away, Mattie,' said Freddie.

Still in make-up, his skin like a kid glove, his eyes lined and ringed with black, the child clung to the door-handle, his voice broken with sobs.

'You saved me, Miss Wentworth . . . I'd be out of work, I'd never get work again, if you hadn't spoken to Mr Lightfoot . . . I owe everything to you . . .'

Freddie paid no attention whatsoever.

'God who created me,' Mattie went on in a thrilling contralto, 'Nimble and light of limb In three elements free To run to ride to swim Not when the senses dim But from the heart of joy I would remember Him Take the thanks of a boy.'

'I'm deducting thirty per cent this week for damage and nuisance,' Freddie remarked. Mattie, with an

expression of deep malignance, departed.

'He's acting,' said Miss Blewett.

'Worse than that,' said Freddie. 'He's acting being a child actor.' But both of them knew that the children came off stage in a state of pitiful and vibrant excitement that must be allowed to spend its impulse gradually into quiet. Told again and again to take off his make-up in the theatre, Mattie always slipped away and displayed his painted face in the Underground, taking pride and feverish pleasure in the passengers' disapproval. To be glanced at from behind newspapers delighted him. The ambition of all children is to have their games taken seriously. Dodging round Covent Garden and up Floral Street with his reddened lips and doe's eyes, he knew very well what kind of strangers were following him, slowed down to let them catch up, then shook them off just as he turned the corner to the school.

'Is he a genius?' the accountant asked.

'I've got one great talent in the school at the moment, but it's not Matthew Stewart. Mattie is something else. He's a success.' Unwin had become preternaturally sensitive to openings – the word 'success' was one – which might help him to lead the conversation back to the subject of the accounts. He would have liked to assert himself, and sometimes thought that unless some drastic step was taken he might lose his reason. The Bluebell sometimes took his part, but was an uncertain ally. His

scheme was to introduce into the place a third party who would be prepared to invest a bit of money, and to talk rationally. That should not be impossible, because it was his opinion that Freddie, though unanswerable and seemingly immovable, did in fact modify her behaviour a little in the presence of a good-looking man. Unwin's father had acted as the accountant here in the thirties, and about his relationship with Freddie there had always been speculation. Always, therefore, Unwin kept his eyes open for a saviour with, let's say, fifteen thousand in hand, and the high courage necessary to make himself acceptable and turn Freddie into a going concern. Even for her there must soon be a limit to borrowing, demanding, and begging.

On the wall above her head there was fixed a piece of painted canvas which Unwin did his best not to look at. The words upon it, written in foot-high letters and scrolled with gilt, read NAUGHT SHALL MAKE US RUE IF ENGLAND TO ITSELF DO REST BUT TRUE. They were the closing lines of *King John* and the canvas had hung above the proscenium of the Old Vic for the production of 1917. Lilian Baylis had refused to take it down until the Kaiser had admitted defeat; it had been given to Freddie, as a significant parting present, when she left to open her school. In 1940 the Bluebell had suggested touching the whole thing up and brightening it a bit, so that they could hang it out of the window if Hitler's tanks came rolling up

Floral Street. Freddie refused; an unnecessary expense, it would last for at least one more war just as it was.

The words were arranged in a half circle on a blue background, as though soaring through the clouds. Freddie herself never turned her head to look at them, she relied on their effect upon others. And even though he avoided reading them so often, Unwin couldn't get away from them. They were a reproach to reason.

He spoke now of the many new stage schools, mostly concentrating on pupils with freckles and missing front teeth, which were then considered necessary for film and television work, and the ease with which these pupils seemed to get county grants for their education.

'No one takes me to the cinema any more,' said Freddie, 'and the school can't afford a television set.'

'You've probably hardly noticed all these new establishments. And of course I don't mean that you wish them any harm.'

'I do wish them some harm.'

She must have been listening more closely than he'd thought.

'You can run along now, dear,' she added. 'I'm going to sit here alone by the gas-fire a while. I'm in need of a bit of guidance. A Word may come to me.'

Her reference, from time to time, to this Word was the most unfair of all Freddie's tactics, since it was quite out of step with her general shrewdness. It was a mystery,

but not a spiritual one. In the stuffy darkness, in the silence, a chance phrase, usually from something she had read or someone she had talked to recently, would come back to her and strike her with the authentic note. Then, lapped in her armchair, she smiled. The Word was taken to indicate the way through her next difficulty.

It could manifest itself, however, outside the premises. Twice, it appeared, a man with a pale face and a black hat, a different hat, but black on both occasions, had come up to her in the crowded street and said quietly: 'They depend on you.' Or the Word might take the form of a peculiarly trivial inscription − OPEN OTHER WAY UP had served its turn − and there had even been some from Miss Blewett's passing remarks − we can't do more than we can, we all live under the same sky. This last had given Freddie guidance not to repair the roof, which was gaping wide in several places, until next year.

Possibly it was one of these moments of inspiration which had led her to realise that the Temple could be run, on its educational side, with only two teachers, obtained at the very cheapest rate. About this, for once, the accountant and the Word had agreed. It would allow a larger allocation for the fencing instructor, the accent and dialect expert, the Shakespeare coach and for half-crazy old Ernest Valentine who only came in to do *Peter Pan*. Having made a clean sweep, then, at the

end of the previous summer, Freddie had managed to acquire two new teachers, recent arrivals from Northern Ireland, who might be expected not to have found their feet yet.

Hannah Graves was a nice-looking girl of twenty, with too much sense, one would have thought, to consider a job at eleven pounds fifteen shillings a week. But Freddie had instantly divined in her that attraction to the theatre, and indeed to everything theatrical, which can persist in the most hard-headed, opening the way to poetry and disaster. Hannah had no stage ambitions; backstage was the enchantment. Once sure of this, Freddie attacked on another front. Some of the pupils, she pointed out, were little better than waifs, needing only kindness and a firm hand. Of course, the job wasn't an easy one. While the children were working, someone from the school had to go down to the theatres and see that they were getting the amount of education the law demanded.

'That wouldn't be what you're used to, dear.'

When Hannah had undertaken to take the junior class in all subjects for at least one year, Freddie offered the other post to a Mr Pierce Carroll. Carroll, who must have been about thirty, and came from Castlehen, a short way out of Derry, was a much more doubtful investment, but Freddie detected in him the welcome signs of someone who was never likely to earn much money, or even expect to.

'Sit down, Mr Carroll,' she said, without looking round, as he came sadly in. And he folded his long thin legs and sat down.

There was his letter open on the desk, so that he could see, upside down, the pale grey product of his own typewriter.

'Now, let me see, you didn't go to university, no specialised training, no diploma.'

'That's about the size of it,' he replied.

'I'm afraid you don't look particularly attractive either,' Freddie went on, glancing at him to see how he took this. He was quite unperturbed, but acknowledged the truth with a nod, almost a slight bow.

'But of course you've done some teaching?'

'I've taught in the deaf and dumb school at Castlehen. They say that teaching the deaf makes you into a good actor, but it didn't have any effect of that kind on me. I've no ability at all that way.'

Freddie waited for him to add 'I'm afraid', but he did not. Perhaps, indeed, he never was.

'What did you teach to the deaf and dumb?'

'Craft subjects and carpentry, Miss Wentworth, there and at the Church of Ireland Remedial School.'

'What kind of personal response did you get?'

'I'm not sure that I expected any.'

Freddie shifted her ground a little. 'Are you interested in the theatre?'

'No, I wouldn't say so.'

'But in Shakespeare?'

'I don't know Shakespeare well. I must disabuse you of that idea from the start.' He looked up at the faded canvas. 'Those are some lines from his works that you have written there on your wall.'

'Are you fond of children?'

'I am not, Miss Wentworth.'

'Or of teaching?'

'It seems to me right that they should be taught,' he said. All the time he remained quite still, sitting there attentively in a suit of the greenish tweed that is produced for those from Northern Ireland visiting London. Long pauses seemed natural when dealing with Carroll. Indeed, his absolute slowness produced an unaccustomed peace. Freddie returned to the subject of crafts and carpentry. That might be quite a good idea for the boys, who grew restless when they didn't get work. 'There's a good deal of materials needed for anything of that kind,' said Carroll.

'What makes you think that I haven't got a quantity of material?'

Carroll looked carefully, but not critically, round the office. 'I get the impression that there's not much money to spare here,' he said. 'But that's nothing to me, I'm used to all sorts.'

'So am I,' said Freddie. 'You're sure, are you, dear, that

you want to apply for this post? The salary is quite low, and it will stay low. I am offering Miss Graves more, but then she has the diploma.'

'It's very low, I should describe it as exploitation, but it's as much as I can expect with my qualifications. I don't think I shall do any better if I stay in Ireland. When you've reached the point, as Wordsworth says, that you can no further go, then you must try something else.'

'I've never read any Wordsworth.'

'Is that right?' Carroll asked politely.

He had no ability to make himself seem better or other than he was. He could only be himself, and that not very successfully. Meeting Carroll for a second time, even in his green suit, one wouldn't recall having seen him before.

He appeared to be musing on what had passed between them. 'I hope you didn't think I intended any discourtesy just now in saying that there didn't seem to be much money in the place. Looked at in a different way, that wouldn't be impolite at all. There's nothing discreditable in strict economy, particularly in anyone who's well advanced into old age.'

'Perhaps you think it's time I gave up altogether,' Freddie suggested.

'Not at all, we should never give up. That was the point of my allusion to Wordsworth. And if we find that one difficulty is solved, then we shouldn't rest, but look

round for another one. It's a great mistake to live with the past victories.'

'You're telling me this, I suppose, from your own experience.'

'Ah, not at all, Miss Wentworth, I've never had any successes of any kind. But I know that victory is a matter not of scale, but of quality.'

Freddie tried to imagine him instructing Mattie in some craft, but could not. Still, he might pass for a teacher. She suggested a contract, three months' notice to be given on his side, one month on hers, and renewable the following July.

'I'm doing you down, dear.'

'That's right, Miss Wentworth.'

Freddie felt some interest in Carroll, more, perhaps, than in Hannah. She had heard in his remarks the weak, but pure, voice of complete honesty. She was not sure that she had ever heard it before, and thought it would be worth studying as a curiosity.

3

FREDDIE'S was in Baddeley Street, in the middle of Covent Garden, which in itself is in the exact middle or heart of London. In the old Garden of the 1960s the market was open every weekday and in consequence the Opera House and the Theatre Royal rose majestically, beset with heavy traffic, above a wash of fruit, flowers, and vegetables. The world's most celebrated singers had to pick their way to their triumphs through porters' barrows, and for the great performances, when the queue formed at night for next morning's tickets, every empty barrow was full of sleeping Londoners. You could find a niche, too, on the piles of netted carrots which were often waiting in the colonnade of the Opera itself. Evangelists of various religions patrolled the queues late into the night, calling on them to repent, and distributing tracts which lay with the other rotting debris about the Garden. When morning came the starlings woke there earlier than in any other part of London.

* * *

This was the world of the Temple children, who had no playground, and no particular place to eat their school dinner. When the midday break came Miss Blewett unlocked the front door and stood back to let them out. The better-off got themselves something to eat at Tito's Cafe, or at the twenty-four-hour coffee-stall outside St Paul's, the actors' church. The others ran, like little half-tame animals on the scavenge, through the alleys of the great market. By that time most of the warehouses had rolled down their shutters, and the ground was littered with straw and cardboard and crushed baskets, of the kind called frails. But round one corner or another there would be a wholesaler who hadn't locked up yet, or a van loading up for the return journey. Far from wanting to sell cheap, the Garden defended their damaged and unsold fruit, declared they were only allowed by law to sell in six dozens, denounced the children as pests, muckers and bleeders and only grudgingly, on the point of departure, released in exchange for ready money a few misshapen apples or carrots. In this way every dinner-hour was a drama. To cajole the unwilling traders, in fact to Freddie them, was better than bargaining for a stale bacon sandwich from the back of the market public houses, which opened at seven o'clock in the morning and closed at nine. Whatever they got, they ate it at once, sitting on the empty floats. Yet in all those years the

police never had to record a complaint against them. Doubtless they were regarded as one of the hazards of the market, like the rats, like the frails.

The children in their turn were perfectly used to the dilapidation of their school. Maintenance was supposed to be in the hands of Baines, the odd job man, who had once stood in as doorkeeper at the Old Vic, and now called himself a schoolkeeper, but in fact only gave a casual glance twice a week at the boiler and the incinerator. Baines also understood what might be called his dramatic role, as age and mortality's emblem, muttering at the kids' antics and hinting at the heartbreaks of a stage career, which would soon cut them down to size. He was not a skilled handyman and couldn't have undertaken the repairs in any case; that was why he suited Freddie. Although he would never have admitted it, Baines also did whatever cleaning was allowed to take place. With Miss Blewett he constituted the permanent staff. Others, like those two who'd just been taken on, came and went with the seasons.

4

CARROLL and Hannah did not meet until the beginning of term, by which time both of them had found somewhere to live. Hannah had gone straight from her interview with Freddie to the Petrou Shoe Bar at the end of the street. The interior smelled powerfully of feet. Still she hadn't come to London for the fresh air there, there was enough and to spare of that at home. She took off her shoes and handed them over the counter, saying that she would like the heels done at once as she had to walk round the district till she found accommodation. The Cypriot glanced at her and after affixing the new Phillips heels he knocked a number of steel brads into them, flattening the heads. 'You will find somewhere before these wear out,' he said. The two of them recognised each other as people of determination, not fortunate, but not daunted.

Carroll asked Hannah to come and have tea with him after their first week at work, so that she saw his room before he saw hers. She wished then that she'd been able to go with him and help him look and then they

might surely have been able to find somewhere a little less neglected.

'Come on up,' he said. 'Don't worry about all those letters in the hall. They're all for people who used to be here last year.' His room was exceedingly cold. Everything was in order — more than I can say for mine, Hannah thought — except for an open umbrella put to dry before the gas-fire, which, however, he did not turn on. 'We were never allowed an open umbrella in the house at home,' she said. 'One of the aunts thought it would bring bad luck. But I don't expect you're superstitious.'

He reflected. 'I think perhaps I am. It's an article of faith with me that whatever I do is bound to turn out unsuccessfully. I'm sometimes driven, therefore, to do the opposite of what I really want.' Perhaps that was why he put things to dry and didn't light the fire. 'You're too much alone, Pierce,' she said.

He created around him his own atmosphere of sad acceptance. Under the window stood a formerly polished wooden table, and on it was laid out his dictionary and paper and a biro with three refills attached to a card. Carroll told her that he hoped now he'd got to London that he'd be able to commit some of his thoughts to writing.

'So that's where you sit and work.'

'When I sit there I feel as if I'm working.'

Something in Carroll made Hannah feel less innocent,

but more compassionate. He eventually made a cup of tea with evaporated milk, and unfolding a copy of *The Times*, began to read to her aloud. The snow had held up work on the National Theatre site on the South Bank. A small crowd had gathered to see Mr Macmillan . . . 'I read through the paper myself this morning,' he said, 'and I just marked one or two of the more amusing paragraphs, as I knew you'd be coming this afternoon.'

God in heaven, does he think I can't read the paper for myself, Hannah thought. And it was not exactly that he lacked confidence. He showed no more hesitation than a sleepwalker. 'Do you think you'll stay long in this job?' she asked.

He put down *The Times* and looked at her bright puzzled face. 'At first I'd had it in mind to give notice at the end of the first term,' he said. 'But now I haven't.' Then, perceiving that he had made things awkward, he asked her what she thought of the place herself.

Hannah cast her mind back. The children did a half day's education only. If they went to their music, dancing and dramatic classes in the morning, they spent the afternoon in a kind of torpor; if they weren't to go till the afternoon, they were almost uncontrollable all morning. Feverishly competitive, like birds in a stubblefield, twitching looks over their shoulder to make sure they were still ahead, they all of them lied as fast as they could speak. Whether they had any kind of a part in a show or not,

they wrote *Working* against their names in the register
and claimed that they were only in school because there
wasn't a rehearsal that day. The first professional secret
they learned was an insane optimism. Still, all children
tell lies. But not all of them, if reproached, well up at
once with unshed crystal tears, or strike their foreheads
in self-reproach, like the prince in *Swan Lake*.

At least their names weren't difficult to learn. They
pressed them upon Hannah. That was Gianni, the school's
best dancer, faintly moustached at eleven years old, then
Mattie leaning back with arms folded in the back row,
one finger against his cheek, miming concentration, next
to him a very small preoccupied boy who did not speak,
but was indicated as Jonathan, then, as near to Gianni as
possible, the terrifying Joybelle Morgan. Mattie, Gianni,
and Joybelle, whose very curls seemed to tinkle like brass
filings, should none of them have been in Hannah's junior
form, but they were used apparently to going unchecked
from one shabby classroom to another. They wanted to
see the new teacher. They were aching and sick with
anxiety to show her what they could do. – I'm not a
theatrical agent, she told them – I'm here to teach you
conversational French. – We know French, Miss, said
Gianni. All of them could produce a stream of words
and intonations which sounded precisely like French,
if meaning was not required. Give them half an hour,
indeed, and they could imitate anything. Fortunately they

were also able to imitate silence, or, rather, that impressive moment of stillness when a player knows he has carried the whole audience. Even for thirty seconds, which was all they could manage, the hush was welcome.

Otherwise they were in constant agitation. They were flexing their fragile toes and fingers, or trying out their unmarked faces. Mattie's kid-glove features stretched into shapes of incomprehension and joy. He had to keep flexible, he said. Happy are those who can be sure that what they are doing at the moment is the most important thing on earth. That, surely, is a child's privilege. Reality is his game. But what becomes of him if the game he is playing is work?

All they needed was to be noticed, and to be seen not to care whether they were noticed or not. In the lunch break Gianni was rattling about the lockers. He had a top-hat-and-cane class at two o'clock, now his hat was missing out of his locker, also his cane. 'Robbery!' he sang, dancing rapidly, for Hannah's benefit, between the desks. He hoped before too long to start in *Dombey & Son*. His feet prattled and flashed in elaborate practice steps.

'I can do all my pick-ups,' he called, gyrating.

Joybelle appeared and remarked, quite automatically, that Gianni was a pick-up himself, only she'd been told he came expensive.

'She can't help talking double,' Gianni explained. 'Her

parents are in the licensed trade, they have to drum up custom.'

Joybelle gave Hannah a smile, as between two under-standing women. 'I'm everything to my mother. She would have loved me to have a little sister.'

'Called off by popular request,' said Gianni.

Joybelle came close and leaned her brightly crisp head against Hannah's breast.

'When he heard my mother was carrying again my father got something to terminate it. He made mum swallow it out of a spoon. She showed me the spoon afterwards in case I had to come to court and swear to something. The metal had gone all black. It was black, Miss.'

Joybelle had little talent, and although she would not reach the age of ten for another few weeks, it was not difficult to predict her future. She had, as it turned out, concealed Gianni's hat and cane in order to offer them to him later, because she wanted to feel like his slave maiden. Hannah called the afternoon class together and gave out some outline maps which she had brought with her, and on which the children were to fill in the capitals of Europe. She felt indignation come over her, because when they were bent down, with the round tops of their shining heads towards her, they looked like any other class.

Rightly or wrongly, she saw them at that moment as

taking their place in the whole world's history of squandered childhood, got rid of for fashion or convenience sake, worked into apathy, pressed into service as adults, or lost in some total loss, photographed as expendable and staring up with saucer eyes at the unstarved reporter. All that she managed to say to Carroll was that it might in some ways be a pity for the children to turn professional so young. He was mildly surprised, and reminded her that she had only taken the post, wasn't that so, because she was fond of the theatre.

True for you, she thought, although she might have managed to suppress the fondness if her mother hadn't suggested so often that she ought to do so. It was hard to explain, a matter perhaps of the senses. One of her younger sisters felt the same way about hospitals and had said that at the first breath of disinfected air she'd known she wanted to work there. Yes, the scent of Dettol had worked powerfully on Bridie. The convent, too, came at those with a vocation through its fragrance of furniture polish. In the same way Hannah felt native to the theatre, and yet she had never been backstage. She had only lingered outside and wondered in passing. It was all guesswork for her.

Her mother had phoned to ask about her new appointment. What sort of a place was it, a stage school sounded more like a half and half to her, and was this Miss

Wentworth anything to the Wentworths of Ballymoyle whom her mother had known quite well as a girl, and if the school was privately run what kind of arrangements were being made about Hannah's annual increment and pension, also were there any men at all on the staff, men teachers of course she meant, well, Carroll was a common enough name, he might be something to Mrs Carroll over at Mullen who had three sons two grown, one an undertaker one in the bank, but of course there was no need to settle anything in a hurry and she took it Hannah was only having a look round her before she got placed in a decent grammar school.

'Pierce, do you know any undertakers?' she asked him idly now. He began to deliberate. 'Don't worry, it was only my mother was on at me.'

After tea Carroll showed her down the stairs, indicating for the second time the worn portions of the carpet. 'There's one more thing I'd thought of saying to you, and that is that you have the real Northern Irish complexion. I think we really only see it at home, very radiant, very fair. I consider that it's produced by the damp prevailing winds, and by the cold draughts inside the houses themselves. I hope it won't disimprove over here.'

'You must tell me if it does, Pierce. You must tell me the moment I start going to pieces.'

There was a possibility that he might smile at this, but

Hannah felt she couldn't spare the time to see whether he would or not. She left him standing in the dark hall, piled with other people's letters, and took the bus back to the Temple School.

There was no need for her to go back, she was off at four-fifteen and the time was long past that. Indeed it was probably a mistake, and might give Freddie the notion that slave-driving encourages slavery. But Hannah wanted to put the next day's work on the blackboard. This would mean that she needn't turn her back on the class first thing, which is as unwise in junior teaching as in lion-taming.

She had to give up this idea, however, when she found the lights on, and Jonathan still occupying his dormouse space at his desk. Pale, unfathomable, and compact, he raised heavy blue-veined lids from bluer eyes to watch her. Mattie was also there, messing about with the switches.

'You're my teacher,' Jonathan finally said.

'That's love,' Mattie interrupted with peculiar eagerness. Hannah was about to reproach them both for insincerity, but after only a week she had learned how little the word meant here.

'Jonathan's a genius,' Mattie went on. 'He'd have been in *Dombey* before I was, only he was too short. He's grown one and five-eighth inches this year, though.'

He pointed to a series of ink marks, perhaps measurements, on the wall. 'I don't know what you're doing here, either of you,' Hannah said. 'Mattie, you ought to be getting down to the theatre.'

Both of them listened with keen attention.

'What are you doin here, young Jonathan,' said Mattie suddenly. 'Why don't you g'wan home?'

Hannah recognised immediately her own Belfast accent.

'I'm just waitin, mister.'

'And what are you waitin for, little man?'

'I'm not waitin for annythin, mister, I'm just waitin.'

'You have to be waitin for somethin I'm tellin you, what are you fuckin well doin then?'

'I'm trainin to be a waiter.'

She was not self-conscious and never listened to herself, but surely if she did she wouldn't sound like that, not as hard as that, not at all like that really.

'Have we hurt your feelings?' they asked, delighted.

'I don't want your pity,' she said.

Mattie offered her a cigarette. 'They're American. I get given these things. They're Peter Stuyvesants.'

Hannah did not correct his pronunciation of this word. Mattie took out his little silver lighter.

'Jonathan isn't really allowed to do imitations. They're bad for his acting.'

'You have your dialect classes,' said Hannah coldly.

'Ah, holy smoke, those same dialect classes is no good

at all,' cried Jonathan, 'you want to see the lines she's givin us, Jesus, Mary, and Joseph [falling inflection], is it a star you're wanting to make of me, why I'm thinkin that if I crossed the ocean to Hollywood that does be in America by the time I got there I'd surely be drowned. Talk is it? In the length and breadth of the Old Country, Miss Graves, I'm asking you did you ever hear talk the like of that?'

'I haven't been over the length and breadth of Ireland,' she said, 'but I've certainly never heard anyone talk like that.'

Jonathan nodded serenely. 'We'll refuse to do it. We'll tell her you said she was an old fraud.'

He broke away from Mattie, whose arm was round his neck, and without a single glance behind him, walked backwards out of the room.

'He's been practising that,' Mattie remarked. 'He'll go on until he gets it right.'

'Hasn't he got it right now?'

'Not that time, he wasn't exactly in the middle of the doorway. I can do it, though, I'll show you some time.'

'Show me now and then go off home, I've had quite enough of you.'

'No, not now.'

He pulled the door to, and began in a low confidential tone to explain everything. He had no parents alive, or, if he had, he didn't know them and had never known them.

He was run by an agent who had a place the other side of the Garden and there was a room of sorts there for him, this agent collected all his fees and paid the school and he didn't know if anything was being put aside for him or not. He got one pound ten a week spending money, but the agent, well, anyone could call themselves that, kept putting it to Mattie that he could earn a sight more if he left the Temple and went in for commercials, that is, if he could fix himself up with some freckles. Hannah was given to understand that it was impossible to get work advertising cornflakes without freckles. But there was some stuff you could use to bring freckles on, Mattie said. It was like the stuff blacks used to use in New York in the days when they wanted to look lighter, only in reverse. You had to grease up and let it work through a bit here and there, like acid. They mustn't be too regular, you wanted more across the nose. The pain screwed you up. Of course some people minded pain more than others. That was called your pain threshold. – Hannah asked how the freckles could be removed when no longer wanted. Mattie rolled up the white of his eyes and spread his hands out; no idea. His whole manner changed as he spoke; he sounded tired to death, close to the gutter.

'Who looks after you when you get back, Mattie?'

'What looking after, Miss?'

She had meant his dinner, of course, and his clothes, though he always looked as smart as a child could.

'That's part of the job, that's all part of the agent's put-on, Miss. He's got a Hoffmann presser in the basement.'

Hannah would not ask what or who this was.

'We have to go out looking okay,' Mattie pursued, 'I don't know what he'd do to us if we didn't go out looking okay.' Perhaps a Hoffmann presser was an instrument of torture. 'I'm really in his hands, you see, Miss. Until I get a bit older, I'm helpless.'

Hannah, feeling the tears of indignation rise, turned away to clean the blackboard. She wondered how Mattie had dared to let himself get into trouble at the Alexandra. All his freaks, and in particular his extravagant affection for Jonathan, were excusable from a waif. Something might be said to that effect. However, when she looked round he was gone.

5

THERE was something uneasy in the friendship between Mattie and Jonathan, which was not a childish matter, and indeed not exactly a friendship. Hannah soon came to know how they were likely to behave, but not why. Anxious though she was to do nothing of the sort, she went to consult Freddie, who said, 'I'm glad you've turned to me, dear, very glad.'

Hannah explained that she was distressed at the thought of Mattie's home life, if it could be called that, and hardly knew whether he ought to be encouraged or kept under.

'It's not that he's deprived, exactly. He gets one pound ten a week to spend on himself.'

'Considerably more than that, in fact,' said Freddie. 'That's one of his troubles, yes. Wealth produces its fantasies, like poverty.'

'Well, what fantasies does he have?'

'They take various forms. Unfortunately he has noticed that there are more important things than money. I may have taught him that myself. I'll have to have a word with his father.'

'What father?' Hannah asked.

It turned out that Mattie's father was the prosperous owner of a chain of dress-shops, Ragtime Ltd, and that his mother, who was as shrewd as they come, was actively concerned with the business. A luxurious home was maintained in Hendon, Mattie was their only child, though Mr and Mrs Stewart were often abroad. And the agent, the one room to go home to, the Hoffmann presser? 'He must have been thinking of Jonathan, dear. Jonathan doesn't seem to have been very necessary to his parents. We never hear anything about them, anyway; we have to make all his arrangements with the agents.'

'But he's only nine,' said Hannah.

'A little bit of anxiety there too, dear. He seems to be growing rather slowly. They've been paying for him for two years, and they wonder when they'll get a return on their money.'

'What do you say to them, Miss Wentworth?'

'Shakespeare, dear, Shakespeare or nothing. I remind them that you only get a great actor once every fifty years, or, indeed, a great man of any kind. And without a great theatre you never have a great nation ... Of course, you want your actors tall enough to be visible from the back of the stalls. They've paid to see them, dear. But they'll only have to wait a little longer for Jonathan.'

*　　*　　*

Casual and lordly in his attitude to everyone about him, unless he hoped to get something out of them, Mattie was none the less obsessed by Jonathan. Constantly he tried to manoeuvre himself into what should have been his natural position of patron. But Jonathan was self-contained. Undemanding by temperament, he made do with very little. Mattie himself needed a number of rapidly changing items — sharp jackets, a new trannie, cigarettes in fifties, and so on. Jonathan gravely admired these things, indeed appeared to be impressed by them, but did not covet them. What is the use of admiration without envy? But Jonathan, secreting himself and watching the world as a passing show, appeared to have learned something so important that his whole time was taken up in considering it. Mattie would have liked to knock him black and blue and bend his little finger back to make him tell what it was. Only at rare intervals would Jonathan join in with him, as a kind of double act, as on the evening when they teased Hannah. Then Mattie became dangerously exalted.

In almost every observable way he was Jonathan's superior — older, better looking, more intelligent, born to success in the profession — not a good voice, it's true, it was light and rusty, but a wonderfully expressive dark-browed face which would carry across any theatre, and, young as he was, a completely finished personality, exactly the same on stage and off. Under his affectations

he was as hard as iron. That was his chief asset, and assets are there to earn interest. Mattie looked you straight in the face, and then turned away with a caressing sidelong glance which in middle age would doubtless become horrible to see, but what triumphs, in the meantime, it would bring him!

He showed off perpetually. Jonathan, on the other hand, was silent for long periods, and was the only child at Freddie's who had no audition piece. He could no more be tempted into a display than a hibernating animal. Then, when he emerged, apparently knowing his own times and seasons, he would become something quite other, doing a speech or two, or dividing himself in order to turn into (for example) two elderly men he had seen through an office window, one short, one tall, getting ready to go home, and helping each other on with their coats. They dusted each other off, the short one stretched, the tall one discreetly bent down. All this was not so hard to imitate, but Jonathan suggested also their tenderness for each other's infirmities and a certain anxiety, about which he could have known nothing. After a bit the scene disappeared as he subsided, sticking his chewing gum back into his circular cheek.

As an actor, he needed an audience, but did not mind who it was or what they said. This drove Mattie into a fury of activity. Indifference is an unfair defence, and amiable indifference — because the little boy liked him

and was always glad to see him — is the most unfair of all. He could not be satisfied until Jonathan had got into some sort of trouble. Then would be the moment to rush luxuriously to his assistance. But there were so few opportunities, one must be continually on the watch. Prompting, for instance, was never needed. If Jonathan didn't know his lines (and he was not a quick study) he smiled, and read them from the book. If he had no dinner money, the girls gave him Fruity Snacks. Once or twice, however, he complained of a stomach ache, although in a detached way, as though the pain was the responsibility of someone else. Then Mattie was in his glory. Lay him down near the radiator, Miss, and keep him warm, I know just what he has to have, I'll go down to Miss Blewett for the Bisodol, you want to be careful, he might get a lot worse quite suddenly, we had to get a stomach pump to one of the cast on Saturday. — He was thanked of course, but it was never enough. He could not master the half-sleepy mysterious gum-chewing little rat of a Jonathan, or exact the word of approval he wanted. Later he rolled him over on the washroom floor and banged his round head on the concrete as though cracking a nut. 'Has that cured your bellyache?' — Jonathan considered, and said he would tell him later. Mattie was outraged. And yet his dissatisfaction showed that he was not quite lost. It was the tribute of a human being to the changeling, or talent to genius.

All this was indoors. In the street, it became nothing.

Mattie, at twelve, could not associate there with a nine-year-old. The illusion, which was the most genuine thing in his life, vanished. His glittering bike carried him away, while Jonathan was left kicking a can along the gutter.

Freddie was also obliged to court Jonathan, whose round gaze met hers with unblinking politeness, but no more than that. When distinguished visitors arrived at the school (and this happened quite often, opening up yet further the mystery of Freddie's past, for all these people came because they had once known her well, and therefore couldn't say no to her now) the children were usually called upon for a display. Jonathan was never anxious to be produced. He brought neither his joys nor his sorrows to Freddie. More woundingly still, he took them to the Bluebell. Only she could soothe his anxiety over the matter of growing tall and starting work. They would sit together and play a gambling game with liquorice allsorts. Miss Blewett handled the lurid sweeties with a certain air, having worked, she said, in younger days at a casino at Knocke-le-Zoute. When the game had got quietly under way, she would make kindly suggestions. Perhaps Jonathan might be auditioned for this year's *Peter Pan*. Christmas threatened, the *Peter Pan* season would start soon. Mattie and Gianni had both got started as Lost Boys.

Peter Pan himself, of course, was obliged never to grow up, so that he could always have fun. The problem at a

stage school is not to grow up, in order to earn money. Jonathan was well aware of the threatening years ahead. Between the ages of twelve and sixteen it is very hard to find work in the profession.

'But you ought to talk to Miss Wentworth more,' Miss Blewett told him. 'After all, we expect great things of you, and it's great things that she's always stood out for. You ought to be with her now, really.'

'You wouldn't like it if he was,' said Mattie, hovering.

One late afternoon, however, when Freddie was approaching the rehearsal room, Jonathan stood in front of her, faintly troubled, and said: 'I don't think you ought to go in there, Miss Wentworth.'

'For what reason?'

He only repeated, 'I would rather you didn't go in there. On the whole, I think you'd better not go in there.'

'Did you ever know me to change my mind, Jonathan?'

He tugged at her shapeless sleeve.

The door opened and seemed to cast forth Mattie, feverishly excited, surrounded by admirers. He was in drag. The grey wig and spectacles and drooping cardigan were a hateful miniature of Freddie; she was faced by her shrunken self.

'Shakespeare would have been pleased, dear,' shouted Mattie, wound up to his highest pitch.

The light gleamed on large brooches and semi-precious

stones, pinned to his padded breasts. He saw her look at them and his coarse confidence ebbed.

'I found them, Miss Wentworth.'

'So have I,' said Freddie.

But she was not really attending to him. What interested her was that Jonathan should have tried to warn her off. It was not like him, he must have wanted to spare her a shock. Possibly, however, he had been trying to spare Mattie.

6

PIERCE Carroll's experience of teaching at Freddie's was not much like Hannah's. She couldn't help being aware of this, because they had such a very thin wall between the classrooms.

It might have been anticipated that among these unruly children of artifice and real and contrived emotion, Carroll would be unable to keep order, and he couldn't; but neither, in the end, did he create disorder. Entering the room in his sedge-green suit, with his case in hand, he was greeted, at first, by silence. The Temple children, quivering like a nerve to every change in fashion, could hardly believe that they were to be taught by a being in such trousers, and with a tie held back by a metal clip, and with such a haircut, which might have been the work of a hedger and ditcher. When he laid out his books and announced a course on the history of the British Commonwealth, uproar was poised, then broke in waves from the back row to the front, where the desk-lids slammed and clashed like the teeth of trolls. After about five minutes, which seemed much longer,

the noise died down, seeming to circle, more and more gently, round the unperturbed Carroll. He said nothing and did nothing. Gradually the class returned to their preoccupations, exactly as they had before he came into the room. Almost entirely ignored, he began to read a newspaper which, warned by previous experience, he had brought with him. He confronted children talking to each other, with a little music, one of the boys having furtively plugged his electric guitar into the skirting. This last Carroll found soothing. He liked to listen to an air. He was teaching them nothing. But there was no violent disturbance and every human being in the room seemed content.

Freddie knew very well, without leaving her armchair, what was happening upstairs. After a week or so, she levered herself out of it and issued forth to patrol her territory. She listened for a while outside the door of Carroll's classroom. When the children had gone home she sent for him.

'They were talking, Miss Wentworth,' he explained, 'just talking.'

'Well, what about?'

'The front row were talking about a film they had seen, *The Young Ones*. There's a singer in it, it seems, Cliff Richards or Richard, who takes a leading rôle. I haven't seen it myself, so I can't offer you an opinion. The back row was discussing what they considered the overcharge

for potato crisps in your canteen here. A boy in the back corner was asking one of the girls whether she knew how to give a French kiss. Let me see now.'

'Why weren't you giving them a lesson?'

'They're not disposed to listen to me, Miss Wentworth. They find these other subjects more absorbing. And there's another point at issue here. It seems to me that these children don't care about a formal education because they intend going on the stage. Now, if I tell them they must work hard at their books in order to earn a living, won't that be showing them clearly that I don't expect them to succeed in the theatre? Am I right now?'

'Have they taken no notice of you at all?' Freddie asked.

'I wouldn't say that, no, one of the girls showed me a pair of shoes she'd bought that morning and asked me didn't I think them sexy. She struck me as an intelligent kind of girl, intelligent in her way.'

Freddie was not annoyed, only curious about a kind of incompetence – or perhaps it was competence – that she had never met before. Curiosity always brought out the noblest in her.

'I simply want you to go in there tomorrow and teach them something, even if it's only how to blow their noses with their fingers. I'm being merciful, dear. We'll forget about what has happened so far.'

Carroll knew that mercy is a function of power. He replied gloomily, 'I hope you haven't it in mind to dismiss me.'

'To tell you the truth, I'm rather surprised that you should want to stay here.'

'I want to stay.'

He was not seated in her other armchair, but standing doggedly.

'Run along now,' she said.

'I'm in no hurry, as it happens. I'm waiting for Hannah to finish so that I can go in and ask her if there's any little thing I can help her with.'

Freddie now understood why this uncouth creature wanted to stay at the Temple.

'Do you always do that? Do you always wait in case there's something you can do for her?'

'It's the best part of my day, Miss Wentworth.' A day had to have a best part, he added.

Freddie's eyes seemed to become opaque, like smoked glass. She did not notice when her employee left the room.

In the main, she preferred the staff to be at loggerheads. They were easier to control then, or to urge into mild competition. If one of them felt unfairly treated, the other would not be displeased. But it was her habit to look for advantages. If Carroll had fallen in love with Hannah — and it seemed quite impossible to tell what he

might take it into his head to do — then in his besotted condition he could be paid well in arrears, and even later than the Bluebell.

With a royal gesture Freddie swept the bills on her desk towards her and began tearing them across, again and again. The sight of them — and one of them appeared to be a court summons — reminded her of the old days at the Vic; dear Lilian Baylis confiding in her creditors, 'I've been praying all night, and God has told me not to pay you just yet.' A Word had come to Freddie more than once, cautioning her against caution. In any case, she was not afraid. She knew that she was one of those few people, to be found in every walk of life, whom society has mysteriously decided to support at all costs.

She looked round the office at photographs waiting to be looked at — a past generation of theatricals framed in blotched silver, a later one in leather, later still in leather-effect Rexine. *Freddie, always, Freddie, who taught me all I know, Ever thine, Binkie, Lest we forget, Noël, À toi, Jean-Louis, Ciaou, Hi Freddie.* Fixed by an indulgent camera in their best profile, they all betrayed the melancholy of those who depend on physical vanity. Their faces were waiting for the betrayal of the flesh. But none of the actors who dropped in avoided the sight of their old portraits. On the contrary, they singled them out at once, prepared to admire their own image in any form.

There were other benefactors there, however, more

important, though their photographs were smaller. Freddie had no need to depend upon her friends in the theatre. Neither did she have to dread time's encroachments. The place could hardly get any shabbier, and Freddie herself had fulfilled the one sure condition of being loved by the English nation, that is, she had been going on a very long time. She had done so much for Shakespeare, one institution, it seemed, befriending another. Her ruffianly behaviour had become 'known eccentricities'. Like Buckingham Palace, Lyons teashops, the British Museum Reading Room, or the market at Covent Garden, she could never be allowed to disappear. While England rested true to itself, she need never compromise.

In a surprisingly short time the Temple children came to take Carroll for granted. At first it had not seemed worth while to try to impress him, then they saw that it was impossible. Joybelle was the last to give up. She told him that she had come round to him, and was even getting to like his haircut – she had looked it up in her Movie Hairdos and it was really a kind of Coupe Sauvage. Would he like her just to run her fingers through it for him, she often did that at home for her uncle, and he said it turned him on. Carroll replied that he was not her uncle. He sat there imperturbably, locked in his own preoccupations.

Hannah missed her family and thought that Pierce must

do so too, and that this might be what made him the way he was. It turned out that he had seven brothers and sisters all told and went regularly to see them, but – and this shocked her – without particularly caring whether he did or not.

'I wouldn't have taken you for a quarrelsome person,' she said.

'I've never quarrelled with any of them. It's just that I don't miss them. When I'm there, I don't know to what extent they notice my presence.'

He needed persuading, she thought, and putting right. 'You can't be expected to be equally fond of all of them. In our family, take the aunts, for example, they have their little ways, haven't yours?'

Carroll considered this carefully. 'My aunts' ways. Well they may have been little once.'

'You're too hard on them.'

'I wouldn't go so far as that.'

'And too hard on yourself. You shouldn't keep thinking about it.'

'I don't think about it at all,' he said with mild surprise.

He was absorbed, in fact, as well he might be, by the strange venture he had undertaken, unprecedented in his family, as far as his own knowledge went. His forebears were middling farmers who married when their financial position justified it, advertising at that time in the *Castlehen*

Eagle for a well-educated young woman aged between 28 and 35, Protestant, and able to play the piano. And these practical arrangements, which had worked so well in their time, had finally produced this Pierce Carroll, who could fall in love. Not accustomed to be proud, he was proud of this, and particularly of the ease with which he had recognised the sensation when it came. One awkward thing, which he never remembered having been mentioned, was that though he wanted to talk to Hannah so much, he couldn't listen to her properly when he did. That was why – although he was saying no more than the truth – he had made such a wretched job of telling her about his family.

Beneath her confidence, which after all did not go very deep, he divined a gentle anxiety, though for other people rather than herself. He longed to bring her peace. A fair old chance I have of doing that, he thought, when have I been of use to anyone? And he felt the whole force of his life's current running to waste.

Meanwhile there she was, confronting life with a certain sunshiny grace, firmly presented in a neat Belfast blouse and matching cardigan. The proximity of the staff-room was a doubtful blessing, unavoidable because the place was no bigger than a cupboard. Indeed, except for the word STAFF painted on the door, it was a cupboard. If there had been four chairs, and four people had sat down on

them, their knees would have touched. Every movement of the elbows was a threat. Much though he longed for closeness, he felt bound to apologise for brushing against her quite so often.

'Just keep the count,' Hannah told him. 'You can beg my pardon every twelfth time.'

In the evening he had not much chance with her, because she had set herself to see every play and every musical in London. The Bluebell, recklessly helping herself from the drawers full of complimentary tickets, was glad to come with her. When they reached the area of light and shadow between the foyer and the front of the house, both of them felt a keen fingering of excitement. Miss Blewett would tell Hannah that she had young eyes and hand her the tickets, so that she could make out the seat numbers.

Carroll asked were not most of the shows very disappointing and she replied that on the whole they were, but there was always another one, always tomorrow. This word 'tomorrow' had recently, for the first time in his adult life, come to have a favourable meaning for Carroll. But he declined to come with them to the theatre. He wouldn't make an exception even to see *Dombey & Son*, with Gianni in the chorus. Particularly, he thought, he would not enjoy that.

The fact was that Carroll and Gianni had little esteem for each other. Gianni had told Hannah, with a warm

rush of confidence, that he was far from satisfied with his education. 'As I see it, there's two things that aren't right about Sir, I mean from the point of view of his job. He doesn't know anything, and even if he did he can't teach anything.'

'I can't listen to complaints about other members of the staff, Gianni.'

'I want to begin trig. Joybelle shouldn't be allowed into Mr Carroll's maths class. Sex and trig aren't compatible, right? My father's not satisfied either. He's very ambitious for me.'

'Perhaps he could find time to come and talk it over, if he's free during the day.'

'He's a tailor.' There were plenty of customers, it seemed, because Gianni's father could do the Italian styles, but the trouble was that he had no faith in himself, owing to his nerves. He'd sit in front of the lengths of cloth, it was all piled up in the front room, months passed, and still he couldn't bring himself to make the first cut.

'What do the customers say?'

'That's it, Miss Graves, you got it in one. They're getting restive. That's why I expect he'll eventually be largely dependent on my earnings.'

Hannah looked at him steadily.

'Are you sure your father's a tailor, Gianni?'

He was outraged.

'Christ, Miss, you don't believe me. I'm not a liar. I'm not going in for acting, you know that, I'm a dancer, my style's hat and cane like Frankie Vaughan, Frankie's given untold sums to selected charities.'

Hannah promised to see Gianni's father if he came to the school. Fearing to give pain, she did not repeat any of the conversation to Carroll. But she need not have worried. Carroll had never had any illusions about himself, and now he had no hopes either. This made him a considerably stronger character than he looked.

7

DEBT collectors had long since given up waiting at the front and back doors of the Temple School. They knew there was no prospect of getting anything, and it was said that one of them, in the manner of the old comedies, had been persuaded to part with his waistcoat and jacket and donate it to the stock of costumes. 'He gave them to Freddie's Frocks, dear,' said the Bluebell with loyal vagueness.

The summons, however, which Freddie had torn up with her bills, returned not long afterwards in the form of a court order. The bailiffs arrived, representing a firm of sheet-music suppliers. They left empty-handed. Nothing could be distrained upon, because nothing, so it appeared, belonged to Freddie herself. The office furniture, to Miss Blewett's surprise, was all of it, even the two armchairs, insured in her name. The bits of scenery, the tattered props, the hats and canes, were all untouchable because Freddie claimed them as her tools of trade, which cannot be seized. A British citizen has an inviolable right to his or her tools, and his or her bed. Where was Miss

Wentworth's bed? The bailiffs learned this when they tried to remove a couch, upholstered in dark red velvet, from the rehearsal room. It was of some value on account of its historic associations, having been given by Ellen Terry to her son Gordon Craig, and by him to his distant relations, the Gielgud family. But it seemed that Freddie, who lowered herself on to the whining springs, slept there always, if she slept at all.

After the men had retreated to ask for further instructions, an atmosphere of high carnival reigned in the office. Miss Blewett could have done with a double whisky, but Freddie, exalted and glowing, needed nothing. The challenge had been enough for her.

'A Word came to me, dear, but I don't know where from. "It's a great mistake to live with past victories." I seemed to hear it when they were looking at dear Ellen Terry's sofa.'

'I know where it came from,' said Miss Blewett. 'It was something that Carroll said to you when he came to see about the job.'

But Freddie thought this impossible. She was in splendour. It could not truthfully be said that she looked young again, but she looked indestructible.

London's theatre received the familiar news of hard times at Freddie's. There are only two professions — the stage and the bar — where generosity is a habit. Contributions arrived at once from old pupils who had

made it, and those who hadn't dashed off cheques with the recklessness of the insecure. The cast of *Dombey & Son* had a whip round. The Old Vic audience sent just short of four hundred pounds, with a note from the gallery regulars, 'Shakespeare would have made it five.' No one knew how things stood about Freddie's furniture. Vans pulled up in Baddeley Street and began to unload gifts of tables and chairs. The Haymarket, most congenial of all theatres, despatched the grand piano from a long run of *Moonlight Sonata*. To take it upstairs would have been risky, and so the fine Bechstein was urged into a mouldy salon next to the staff-room, where two of its legs sank through the floorboards and it remained as though wading ashore.

Freddie looked on, with the calm of a born survivor, at the arrival of lesser pieces.

'We shall get a good price for some of these, dear.'

'They were gifts!' Miss Blewett wailed. 'Given from the heart.'

'That's so. That's why it wouldn't be right to send them back.'

'But what will everyone say?'

'They'll say I'm just the same as ever. That's all they want from me, you know.'

Remaining the same requires an exceptional sense of balance. Was it possible — and curiously enough it was

her refusal to worry which suggested this — that Freddie
was losing this sense, if only to a small extent? Perhaps so,
because it was now that Mattie Stewart's father, who was a
watcher of situations, chose to try something which he'd
had in mind for quite a while. He asked whether he might
introduce to Miss Wentworth a business acquaintance of
his called Joey Blatt, who might like to invest something,
he couldn't of course say how much, in the school.

Mr Stewart did this not out of affection, but simply
from impatience at the sight of mismanagement; anyway,
it looked like mismanagement to him. He had no com-
plaints about Mattie's progress, the boy got all the stage
work regulations allowed him to do. But the goings on at
Freddie's, from a business point of view, were lamentable;
one might say that they wouldn't satisfy a child. He
hadn't much confidence in the accountant, Unwin, and
couldn't spare time himself to see what needed putting
right, but he thought Blatt might be able to. At the very
idea of profits going to waste, even if they didn't concern
him directly, he felt a mixture of wistfulness and anger,
like a poet conscious of all the roses that fall.

Blatt confirmed the appointment Stewart had made for
him, and didn't think there would be too much difficulty.
He had always been concerned with small businesses and
couldn't believe that it would be a complicated matter to
buy himself into this one, which was scarely a business
at all. This Miss Blewett, for example, although Miss

Wentworth referred to her, when it suited her, as 'my partner', was in fact nothing of the kind. There was no formal agreement, if Stewart had got it right, no division of the profits, if any, and no consultation. Miss Wentworth, then (though the description hardly seemed to fit her), was a sole trader. The Baddeley Street lease was in her name and had another fifty-nine years to run. She had managed to renew it with the ground landlords during the war, when property did not look to be worth much, and had claimed enough War Damage to patch it together afterwards. Blatt was surprised that the old lady should have been able to put through anything as sensible as this; it had been one of the first things that induced him to look at the proposition at all. What he had in mind was a private limited company with himself as director and Miss Wentworth as the other shareholder. He was in the company registration business himself in a small way, so he could put the memorandum in hand at once. This Miss Blewett wouldn't come out of it very well, but she probably wouldn't be treated any worse than before. The important thing, if they were going into TV work, which was of course essential, was the business name. 'Freddie's' or even 'The Temple' meant a lot, but they didn't at all mean what Blatt wanted. Bright Kids, Kids on Tap, Movers and Shiners, any of these might get a good response, that was, they might motivate the consumer.

He tried these thoughts on Stewart. 'Of course, none

of this is going to affect a serious career like your Mattie's.'

'Nothing's going to affect Mattie.'

'Or that other one that you told me about, the one that's not yet tall enough.'

'You've got to concentrate on talking Freddie round. It's that you should be thinking about. Kids on Tap and the kids themselves, you can worry about them later.'

Blatt felt he ought to be able to understand old women and children. If not, where was his native facility? He had his mother still alive, and his grandmother.

'You won't find her much like your grandmother,' said Stewart. 'But I want to wish you luck.'

Blatt, then, was making his attempt where Freddie's brother, and several others, whose projects were now no more than whitening bones, had failed before him. Fortunately, he didn't know this. Unwin and Miss Blewett, who did know it, were both of them astonished that he should have been encouraged at all. Perhaps Freddie had received a Word about him. Or perhaps the last crisis had had its effect on her. Unwin, however, didn't think this was it; the accounts, though worse than they had ever been before, were not much worse. On the morning of the appointment he brought along the balance sheet, having tidied it up as much as he decently could.

'Put it away,' said Freddie, in the tone she used to the local flasher.

'Surely a discussion should have a basis of substantial fact.'

'Not if it's with me, dear.'

Miss Blewett reported from the front window that Mr Blatt was coming, and that she felt sure it must be him and so it was, arriving after the delay inevitable to those who didn't know the district's one-way streets and cul-de-sacs. They could all see him, dark and dapper, cutting short whatever the taxi-man was saying and tucking away his notecase. Apologies and explanations for lateness often took up the first ten minutes of an interview, and gained Freddie a distinct advantage. But Blatt said nothing at all about it. The time spent during the taxi's meanderings had given him a chance to arrange his thoughts exactly.

He began very effectively by saying that Miss Wentworth would probably want to know a bit about him and his interest in the theatre and in stage schools in particular. He described himself as someone who liked a show but to whom Shakespeare didn't mean much. – I can't think why we need this Blewett woman here, he kept thinking, or that greaser Unwin, I could have a chat with him later. – Well, in the same way that he couldn't get on to terms with Shakespeare, and never had been able to, so there must be pupils with very different capacities in the school, all kinds, really. Some of them probably came from pretty rough districts.

'I did myself,' he said, turning to each of them with engaging frankness. 'I lived in a rough part, and that's why I know what they're like.'

'And do you think I don't?' Freddie asked him.

Blatt smiled.

'I don't suppose you've spent much time in Mission Street, E.14.'

'I knew it very well as a young woman. Well, let us say, as a woman. Old women are something different.'

'Social worker, then.'

'I lived there because I was poor.'

Unwin couldn't hide his amazement at this quite new variation on Freddie's former life and times. Blatt, against all his resolutions, felt himself possessed by an agony of rage at what seemed to him a monstrous and gratuitous lie, introduced for the sole purpose of putting him down, and rejecting his traditional plea for sympathy. Mild blackmail on the subject of humble origins should surely be acceptable everywhere. He could see that Unwin didn't believe this tale either, mistake to employ a man like that who couldn't conceal his reactions.

Freddie watched him with interest, and took the opportunity of the pause to say; 'You have the hands of an artist, Mr Blatt. Has anyone ever told you that?'

Strong enough to ignore this, and leaving his hands exactly where they were, spread out upon his knees, Blatt

still could not quite control his voice and broke out in an uncertain baritone:

'You don't know Mission Street, that you can't make me believe, you've never been within miles of it. If you lived there as a young woman, pardon me, kindly pardon me for saying this, that must have been in the early nineteen-twenties, when my great-uncle's business was on the corner of Mission Street and the Commercial Road. If you were familiar with the district you would have known of my great-uncle.'

'Well?'

'Well then, Miss Wentworth, what did he die of? You tell me that!'

And everything, to ridiculous degree, seemed to turn on this.

'His name was Blatt as well?'

'Yes, my grandfather's brother. A leather business, he was in leather. What did he die of?'

Freddie smiled. 'You mean, don't you, how did he die? I don't think the police were ever quite sure.'

The Bluebell knew that Freddie would never have gone so far if she had not been sure of her ground. She could not bear to watch the discomfiture of the smart business man. At this moment the office door was opened a little and Jonathan trustfully came in. She made a sign to him to go away, but he looked at Freddie, and recognised that he was welcome.

'This is Mr Blatt, dear.'

Jonathan shook the visitor's hand. He was wearing blue jeans, as always, but gave a curious suggestion of a Victorian child, woken and brought downstairs to the drawing-room in the middle of the night.

'Mr Blatt has come to tell me that I don't know how to run my own business,' Freddie went on.

'Oh, surely that can't be so, Miss Wentworth.'

'He says he wants to help the school. He's anxious to give me some money.'

'What is money?' Jonathan asked.

'Now look here, son,' said Blatt, 'you know what money is.'

Unwin felt that if no one else was going to put a stop to this, he must, particularly when the little boy went on, in a sleepy whisper that chilled the blood, 'Money isn't cruel, is it? But if it isn't cruel, why didn't it save my mother?'

'I can't think that it's useful to have the pupils coming in here at this stage,' said Unwin. 'Miss Blewett, surely he ought to be somewhere else?'

'I only came in to see if she'd like a hundred up at Allsorts,' said Jonathan, quite himself again, as he left them, if it could be decided what that was.

Blatt, saw that, after all, there was something to be said for Unwin. He rallied gamely, largely because he was convinced that the boy had been brought in on purpose

to impress him, as a kind of talent demonstration. To the end he never understood the fluid nature of the Temple School, where the children, as a relief from their hard training, wandered to and fro almost at liberty, nor did he grasp the nature of Freddie's benevolence. As a matter of fact, he *had* been impressed; he hadn't meant to say, 'Now look here, you know what money is.' He seemed to have been made to say it, by the line he had just been given. There was talent, then, in that boy. This made him all the more anxious to press on with his scheme.

As he saw it, the demand for kids on TV was expanding and would expand, but their faces only stayed commercial for about six months or less, then their noses got too big or their teeth went wrong, or the viewers got sick of seeing them. Better, then, if they only stayed at the Temple a term or so and then left with the money they'd made, just like the Japs used to run their light industries, girls worked in the factory till they'd collected enough for their dowries, then back to the village, no trouble or fuss that way, smiling and bowing all round. The system worked well, very well indeed. Naturally they wouldn't drop the long-term training and the Shakespeare completely, that was the biggest asset, really, apart from the leasehold, the only asset. She would be the figurehead. Very probably they would still train up a few stars, you couldn't miss star quality, but in the main it

would be a quick turnover, and probably they'd be able to cut down the teaching staff by at least fifty per cent.

'That would only leave me with one teacher,' said Freddie, who had been studying him, rather than following him, intently. Blatt was disconcerted.

'I saw an attractive-looking young lady in the hall as I came in.'

'That was my fifty per cent. She has a colleague, who is not so easily noticed.'

Obviously the next step must be a tour of the premises. But Unwin, mindful of the mouldering floorboards, suggested that they could leave this till later and that they might now adjourn to his own office in Bishopsgate to glance through the accounts. He had put aside the morning for this, he said. An expert in the streets' complexity, he dislodged a taxi almost at once. As soon as they had got in and the door was shut, Blatt spread out his hands and looked at them.

'I've never thought of them as different from anyone else's.'

Freddie was not displeased with herself. 'He was surprised, dear, that I knew about his great-uncle. That was old Max Blatt, who broke his neck falling down the cellar steps.'

Miss Blewett, having committed a good part of her life, and the closing years that lay ahead, to the Temple School, had to stand up for herself sometimes. Blatt's

propositions would not do, but she was reluctant to see him disappear, with his investment capital, over their horizon. He might be the last of his kind. She did not believe that Freddie had taken him seriously for one moment.

And yet, perhaps because he had not admitted defeat, he was not dismissed. Somewhat to the neglect of his other interests, he continued to drop in at the Temple. And Freddie continued to withhold, from her store of unforgivable remarks, the insult which might part them for ever.

8

AUTUMN was Freddie's best season — in a sense, her spring. Comparison between her old age and the approaching winter worried her not at all. She, to all appearances, stayed the same; it was only the year that turned. When the October winds drove sodden leaves and bits of packing straw and dropped theatre programmes round the gutters, Freddie, although she never dined out, emerged sometimes for an evening stroll.

Unsavoury Baddeley Street, as the Temple children's playground, was also Freddie's village lane. Next to the school was the character-shoe store, which also did duty as a sex shop. Miss Blewett thought that Joybelle ought not to run in and out quite so much; Freddie replied that she was probably giving them a few tips. Then came an agency which did accommodation addresses, Tito's smelly cafe, a small chemist who sold make-up a good deal cheaper than Leichners, another agency, and the Cypriot who had mended Hannah's shoes. But now that it was dark the upper air trembled with the fiery brilliance of the theatre lights from a dozen streets round

about, while in the narrow glimpse of sky above the night clouds glowed with reflected red. The street, whose own lights were dim, was transformed into a kind of coulisse, waiting for the overture.

Two hundred years earlier, when slops were emptied direct out of the plain flat-faced houses, the smell must have been if anything less strong than now when great gusts of vegetable odour from the market floated above the heavier diesel vapour and a hint of the cafe's drains. But Freddie thought poorly of fresh air. In particular she believed that the theatre should never be exposed to it, or taken outdoors, or brought to the people. The theatre was there for audiences to come to. At this very moment they were hurrying off from work, bolting their macaroni cheese (Freddie's heart was always with the cheaper seats) and braving the struggle back into the city, to concentrate on what was said and done in a lighted frame, which, when it went dark, would make them cry to dream again. They were creators in their own right, each performance coming to life, if it ever did, between the actors and the audience, and after that lost for eternity. The extravagance of that loss was its charm.

At the school itself, most of the children were in autumn work. They had calls for suburban pantomimes. *Dombey & Son* continued to run, and it was given out that *King John* was coming on at the Nonesuch. This play Freddie considered, in justice, to be her own property.

The faded and flaking NAUGHT SHALL MAKE US RUE on the office wall seemed to give her a hereditary right to it. The part she coveted was that of little Prince Arthur. With a tear-raising scene begging mercy from his gaoler, who has orders to blind him with red hot irons, and, in Act 4, a spectacular death on stage, Arthur must be one of the most nauseatingly sentimental and theatrically effective parts that Shakespeare ever wrote. Considering how much he seems to have disliked children, it does him great credit. And really he might have been pleased to see the ferocity with which Freddie chased the part, to make sure of it for her own.

While the office was so busy, Hannah was downstairs a good deal, acting as the first and in reality the only line of defence between Freddie and the parents. Sometimes they were newcomers, asking about places and fees. Then they must be encouraged, that is if they knew English, which wasn't always to be counted on. In the autumn the International Circus came to Olympia, and the high trapeze acts, aristocrats of their world, liked to put their children into school for a few weeks. They themselves were grave and sober people, dark-suited like the members of an academy or a bank. Their daughters were exquisite little idols, Delphine, Chantal, Loulotte, jealously guarded from following their parents into the air. They must be dancers. The sons had been left behind,

in lycées all over Europe, to continue their studies for the baccalauréat.

Hannah, speaking her correct French or her little bit of German, assured these anxious parents that the ballet classes were conducted on classic lines and that all the pupils were of good family. There was no rough language, no unseemliness. Something's giving way in me, she thought. I'm getting so that I don't know whether I'm telling the truth or not.

One afternoon Joybelle came to tell her, with a deeply suggestive leer, that Gianni's father would like to have a word with her. There was no waiting room; Hannah came down and saw a little sharp-looking Italian, olive-green in the cold draughts which penetrated the hall.

'Mr Baccelli? I'm Miss Graves.'

'I wanted to consult you about my son. He mentioned you as his teacher.'

'Oh, I'm not his only teacher.'

'Your name was the one he mentioned.'

She asked him to sit down on one of the hall chairs; she saw that he would have liked to dust it off before having anything to do with it, but was too well-mannered to do so.

'Gianni spoke to me about you, too, Mr Baccelli.'

'I expect he told you that I was in business.'

'Yes, he did.'

'I am a tailor . . . does that surprise you?'

Hannah found this difficult to answer. She was ashamed now of having disbelieved Gianni. But there it was, after even a short time at the Temple the distinction between truth, imitation and pretence became lost.

'What did he say I was, Miss Graves?'

'A tailor.'

Baccelli looked at her mournfully, and Hannah hurried on, 'I don't think you ought to worry about Gianni's class work. It's only moderate, but that's because he's concentrating on his career.'

'Yes, he has concentrated. But he has not been chosen for *Dombey & Son.*'

'Oh, they all have to take their turn at that. Perhaps after Christmas he'll be in the chorus.'

'Yes, the chorus, but now I don't think that's enough. I had hoped he would be given the rôle of Little Paul. Then he would sing that beautiful song, *What is money, father, is it cruel, father? If money isn't cruel, why . . . did it let my Mamma die?* . . . My boy knows by heart every word and every note of that song, Miss Graves.'

'Well, I don't really know about the stage side of it, I'm just here for their lessons, but I think you'll find that the Little Paul they've got in the show at the moment is about eighteen or nineteen.'

Mr Baccelli ignored this attempt to pacify him.

'Every word and every note, Miss Graves. And perhaps you're not aware that I've made him a number of stage

suits, in stretch materials, in anticipation of his career. I could show them to you at any time, hanging in his bedroom cupboard.'

'That must have been a great strain for you,' said Hannah warmly.

'I beg your pardon?'

'I remember that Gianni told me . . . I mean it must have been a terrible business for you, making the first cut in the material.'

'Why should that be a strain for me? There is no difficulty there at all.' He stared at her. 'Perhaps I didn't make it clear that I am a tailor.'

Mr Baccelli wrote to say that Giovanni would be withdrawn from the school as from the following term. But Freddie refused, in her autumn jubilation, to look on this as a setback. Gianni was a hard worker, yes, but that was no substitute for talent. What was more, she persuaded Baccelli to present the no longer needed stage suits to the school's wardrobe. Hannah saw them later over Miss Blewett's arm; one Little Paul Dombey outfit, with simulated brass buttons, one shimmering diamanté suit, one with a red, white and blue waistcoat.

'What will we do with that, for pity's sake?' Hannah asked. Miss Blewett replied that it would have a thousand uses.

Meanwhile the Peter Pan classes had already started, and were to go on until the auditions began for the

parts of the Lost Boys. These classes were a speciality of Freddie's. It was perhaps a pity that they had to be entrusted to old Ernest Valentine, who, being, as he said, on his uppers, could not possibly be got rid of. For many years he had understudied the role of the St Bernard dog, Nana. Sir James Barrie himself had once praised his work. Recalling this, as he did every week, he went on to block out Nana's scene exactly, crossing and recrossing the room on all fours and barking in an insane manner. The children refused to listen to him at all.

Old Ernest did not take this in good part, but mingled his barking with growling and with unpleasant remarks about his pupils. The only person in the place he really approved of was Carroll. On several occasions they went together to the Nag's Head in Floral Street; only half a pint for old Ernest, otherwise his kidneys played him up and he couldn't go down on all fours.

Carroll, who knew nothing about *Peter Pan*, had never seen it, and had no intention of seeing it, couldn't quite get the hang of the conversation at first. It appeared, according to Ernest, that Sir James had written an extra scene which had only been played once, that would be in 1908. Wendy has grown up and got married, but in order not to disillusion Peter, who enters through the window as usual, she tries to cram herself into her old dress, but it can't be done, she's developed a bit, eh, and it's too tight, you get me, round *here* and round *here*.

'And what is supposed to have happened to Nana?' Carroll asked.

'She's been getting out at night and going with other dogs, and it's like you'd expect, she's been having a bit of nookey.'

'Is that so?' said Carroll.

For Hannah's sake he would have liked to have been drawn into the enchanted circle. But he simply hadn't the feeling for the stage. He saw now that was a failing in him. He simply didn't understand it. It was quite beyond him why old Ernest, who had never been much more than an understudy, should stand at the bar with his eyes full of tears, talking of the theatre and only of the theatre, and, to the annoyance of the regular customers, barking at frequent intervals. Carroll noticed also, with considerable surprise, the effect which his visits were having on Joey Blatt. Blatt was looking for an investment, no secret about that, and it was only good sense for him to ask questions. But although he could hardly have been satisfied with the answers, he seemed unable to keep away. A glance had shown him that everything could be differently, and better, done at Freddie's. The publicity and safety regulations should be reorganised, the piano shouldn't be standing under a direct leak from the ceiling, even the dance routines could be tightened up. Agitated, canny, and smooth-shaven, he moved trimly through the ramshackle rooms and corridors. In a very short time

he mastered the details of a quite unfamiliar business. All his suggestions for improvement were excellent. But all of them met with frustration, like efforts in a dream, where the way to escape is clear enough, but one can't remember how to walk. Carroll, for example, he spotted at once as a liability. He didn't want to hurt any feelings, but the man was of no possible use. 'I wouldn't say that, dear,' Freddie told him. 'Someone has to talk to Ernest.'

Nothing was concealed from Blatt, but neither was he told what was happening. Freddie spoke to him, and of him, as if he were an old suitor, tolerated through habit. Certainly he couldn't remember it having been mentioned that Noël Coward was going to visit the Temple. 'Just dropping in, dear, I don't suppose he'll be more than half an hour.' But had Noël Coward ever had any connection with the school, in any capacity? Had he ever been there? It didn't seem that he had. But even so, surely there was a lot of publicity value in it, a lot of mileage to be got out of it? Oughtn't the children to put on some sort of display, to impress him? The Bluebell, who sometimes took pity on Blatt and made him a cup of Nescafé in her filing-room, said that the school was quite used to distinguished visitors.

There was, after all, nothing very perplexing about it. On a rapid business visit to London, the Master had heard of Freddie's recent difficulties and had recalled, as he always did readily enough, his own triumph as a child

star in *Peter Pan*. Who exactly had suggested that it would be a kind gesture to go and see Freddie, and give her just a squeeze of the hand, is not clear now, perhaps it wasn't even then. He arrived with two assistants and a male nurse, but all three of these remained outside in the car, which glittered with superb indifference in Baddeley Street.

Freddie was at the front door. The children, leaning perilously from the front windows into the sparkling October air, could just see the top of her head. Then, steering clear of the doubtful floorboards, they skimmed down to the hall to intercept the Master.

Carroll, although he was on duty, did not attend the great occasion. When, at the Master's gracious request for a piano, Freddie led the way to the decrepit salon, Carroll stayed behind, not feeling that he'd be of very much use to anyone. To the classroom where he sat alone in the pale autumn light, laughter floated up, and shuffling, and after that a silence, more alive than any sound. He did wonder – he couldn't help it – how things would go with the half-submerged piano. But he did not know the profession. Noël Coward was singing. The tinkling notes of the accompaniment ascended to wait patiently for the unmistakable toneless half-voice, a kind of satire on itself, blandly enticing. The song was one that Carroll didn't know, indeed couldn't have known; it

had been composed in the car on the way over, entirely
for the occasion. The subject was how many of 'us', living
in luxurious exile all over the world, remembered what
we had learned from Freddie . . . yes

> even in the Medi-
> terranean sun . . .
> When day is done
> And shadows fall
> We can recall . . .
> All those long Shakespearean speeches
> Once more unto the breaches
> Those All the worlds a stage, dear, every one . . .
> Because . . . Freddie, you made it fun . . .

'Freddie, you made it fun,' Carroll repeated in sincere
admiration. The Master, drawing entirely, as has been
said, on his imagination, was giving an artfully faded
charm to reminiscences of something that had never
happened. The voice was resting now and the piano
could be heard only in snatches. Carroll beat time gently
with his biro.

For the first time since his appointment he was
correcting some exercise books. He had not asked for
the exercises to be done, but the children left behind,
those who hadn't got work in the theatre, had decided,
for a day or so at least, to do an imitation of good

pupils. How they could tell what to do was a mystery, and as to the books, he hadn't even known that they'd got any.

While he made his scrupulous ticks and listened to the surge of applause from downstairs, his thoughts turned to the present state of his relationship with Hannah. That could be said to have advanced, by which Carroll meant that at least it was not going backwards. And yet it distressed him. There was something amiss about the effect he had on her, and this must be his fault, for it couldn't be hers. It was this way — Hannah was the most natural creature that ever breathed. Well then, how was it that more than once, when they were talking together, her manner had changed to the kind of nervous arch brightness which used to be thought necessary to signify that one party was female, the other male? For example, he'd been round to her place on Saturday last, putting up the bookshelves for her. He had made a good job of it, and after all a man who can put up shelves properly is a prince, even if it's only for an hour or two. But then afterwards, when he'd put on his jacket again and had a cup of tea, she'd asked him to help her fold a pile of sheets and blankets back from the launderette — the whole place was in a bit of a mess, but he didn't mind that, he didn't mind anything she did — and as they stood there, holding the two ends of the sheet, she'd glanced at him and said, 'My aunts would think I was

giving you the come-on.' There was a convent-school remark for you, if you like. Coming from Hannah, it was more like an impersonation. It might almost have been his eldest sister, who was not likely now to get any kind of a husband. But Carroll, cursed as he was with honesty even in his own dearest concerns, knew only too well what was the matter. Hannah was trying to cheer him up and bring him out of himself, or, worse still, she thought it was the way he expected her to talk.

However, he would see her tomorrow, and that couldn't be taken away from him. In all probability it couldn't, he carefully corrected himself.

The singing downstairs began again, but now there were footsteps, almost running, it couldn't be Hannah though, much too heavy.

'Mr Carroll . . .'

'I think it's time you called me Pierce, Miss Blewett,' he said.

'Mr Carroll, I need help, I want you to . . . after all, you're a man . . .'

'After all what?' Carroll asked. He rose and pushed forward a chair for her.

'No, it's urgent. I want you to come at once. I want you to deal with things, as a man, I mean.'

Carroll looked at her crumpled face. Various possibilities suggested themselves to his mind, and he began the task of rejecting them.

'It's little Jonathan. He's not himself.'

'What is he, then?'

'He's not quite himself, that's what I mean ... just when we have the Master here ... just when he might have had his chance to show what he can do ...'

'Hannah had a word with Jonathan yesterday,' Carroll said, 'and he didn't want to put on an act of any kind. He was perfectly sensible about it. He said he hadn't got anything ready. You can't blame him for not putting himself forward.'

'But Mr Blatt thought he was missing his opportunities, he took things into his own hands, he's always thinking he can improve on our methods here.'

'What is Blatt doing exactly?' Carroll asked. 'I presume he's not behaving like a man, or you wouldn't have come for me.'

'He called Jonathan out of the room, you know the Master is doing a song for us, and he told him that as soon as the applause was over he ought to go right in and do some imitations, but Jonathan just smiled and shook his head, but politely, like he always does. Then when I came back from making sure the car was still there he'd given the child a drink of whisky.'

'How much?'

'And it's only three o'clock in the afternoon ...'

'How much?'

'I don't know, it was out of that flask he has. Really

nowadays you only see flasks like that at race-meetings. It can't be right, Pierce, can it?'

'I don't see what Blatt is doing here in the school at all.'

'He's taking an interest,' Miss Blewett said.

The smell of whisky was noticeable even before Jonathan appeared in the doorway, sidling in, very pale, a debased mannikin gleaming with sweat.

'If you could do something with him.'

'We'll retire to the boys' cloakroom,' Carroll said. He stood the little boy in front of the drinking tap, bent him down, and let the cold stream run hard on to his head. The water bounced off the round dark-furred skull symmetrically, in jets to the right and left. It couldn't have been so difficult to design those Renaissance fountains, Carroll thought. Just get the amount of force right. Jonathan was pitifully sick on the tiled floor. The poor kid. He supported the sopping head, not well able to hear the words.

'I'm not doing it right. I can do drunks, really.'

'Perhaps we could worry about that later.'

'I ought to fall over.'

'No, that would be too much. That would be over-doing it.'

'I wasn't right,' Jonathan whispered.

Worse still, he hadn't got the Master's autograph. He'd been looking forward to getting that all week.

* * *

Blatt felt terribly ashamed of what had happened. As a youngster he had done a bit of boxing, indeed he'd thought at that time it would be the way up for him, and he'd twice been given a nip before a bout, both times with good effect. Everyone kept talking about this little Kemp boy and what great things he'd do next year, and then when Coward had told them — as he had done, just turning round a bit from the piano — that he'd played his first straight part, as a cockney page-boy, at the age of eleven, well that surely was now the moment for the kid to put his goods in the shop window. Still it was crazy. Never in connection with any of his other interests would Blatt have taken such a short cut, not in his mailing service, nor the concession for Seat-U office furniture, nor the kitchenware agency. But then, anywhere else dealing with people didn't seem such a problem, only at Freddie's.

Blatt determined to pull out altogether. Unwin was still trying to press him, of course, but he hadn't managed to finalise anything, far from it. Perhaps he'd give it another month.

Freddie, who was not used to taking either Carroll or the Bluebell seriously, dismissed their account of the incident. If she had believed them, she would have been very angry. But the atmosphere of the Temple, heady as the theatre itself, was now at high pressure, warmed with congratulation. The Master's farewell had

been cordial: 'Play it large, darling.' The next thing had been a telephone call from the multi-storey car park where they were holding the auditions for *King John*. It was from Mattie, to say that he had got the part of little Prince Arthur.

9

DIRECTORS realise that audiences are not likely to have much grip on Shakespeare's *King John*. They hardly know what to expect, except perhaps something about Magna Carta, which doesn't figure in the play at all. Perhaps Shakespeare had never heard of it. In any case, he presents King John as a patriot, misguided, certainly, when he connives at the torture of his nephew little Prince Arthur, but standing out to his last breath against France. In the high Victorian theatre the actor playing the king used to sweep the crown from his head during his death scene and even hurl it into the wings, partly to indicate magnificent failure, and partly to keep some attention for himself. By that time the audience had already seen little Arthur die and his mother Constance run mad, their handkerchiefs were soaked, they had no more tears to shed. King John himself was left ranting on, against unfair competition.

The director of *King John*, 1963, was Ed Voysey, who had avoided reading any accounts of the old performances, in order to keep his mind clear. Certainly there would be

no feeling of competition, no 'matching', just teamwork and open consultation with the cast on disputed points. It was quite obvious to him, however, that *King John* must be played in Edwardian costume. That didn't need discussion with anyone. John had this mother, Eleanor of Aquitaine, in the play, who gave a good deal of trouble; Edward VII also, of course, had an old mother. It would make it much easier for the audience to relate to what was going on if every time John talked about his mother, they thought he meant Queen Victoria. True, England hadn't been at war with France in Edwardian times, but, apart from that, there were almost too many parallels.

Casting was rather more straightforward than usual. One slight hiccup, his Queen Constance was said to be unavoidably delayed in New York and could only manage to be back in time to rehearse her solo scenes. On the other hand William Beardless, who he'd managed to get for King John, preferred to rehearse without any woman at all for as long as possible. Beardless had a very, very high reputation, and was punctual to a fault. With that, though, he was acutely sensitive and had simple, though fixed, ideas of his own importance. Gentleman-scholarly in his approach, he had practised the crown-sweeping gesture and was determined, in the face of any director on earth, to get it in somehow. Ed, aware of this, prepared to sweep it back by force if necessary. For Hubert, the king's henchman, he'd had to fall back on an actor

who had been around a long while, Boney Lewis, a charming drunk who was dependable enough while working, whether sober or not. And Mattie seemed at least well trained. After all, he came from Freddie's.

The first read through was at a church hall in Acton Central, piled with Scout equipment and a set of drums which, the caretaker told them, belonged to the Youth. The lowest paid among the cast arrived first, brightly conscious of opportunity, one of them with a slice of bread in a string bag to indicate virtual starvation. Others appeared to have only just got up, or not to be sure of the time. But they had been up a long while, and they did know the time.

An exception to the nervous gaiety around him, Boney sat heavily on a large reinforced toadstool, the property of the local Brownies. He looked terrible. Beardless reclined on one of the parish chairs, his legs crossed, one fine ankle in one fine hand, head a little on one side in a pose of marked attention. He was disliked throughout the profession for his habit of handing out little notes to the cast after every performance, pointing out, in a friendly spirit, exactly where they had gone wrong. His notebook and pencil were out already. Crouching behind Beardless, fascinated, Mattie waited to make an impression on him. If all else failed, he might try blowing a Scout whistle. He had stolen one already from the store cupboard.

The hall was freezing. One of the walk-ons, said to

understand these things, fiddled about with the screw cap of the radiator, which remained cold as a tomb. The caretaker's old dog, which had been lying underneath the water-pipes, dreaming of warmth, stirred hopefully, and then subsided again. After a calculated interval the caretaker himself came in with a radiator key, which he said he never left in place for fear the Youth should get hold of it. The key made no difference either.

Springing on to the stage with determined agility, Voysey, in a black pullover with a low V, giving a reassuring glimpse of chest hair, leather wristlets, and a gold pectoral cross, welcomed them all. There would be no warm-up, he told them, no judo, no improvisations to get them used to each other, just the exchange of ideas, the sooner ideas were exchanged the better. He held up the brown-paper-covered book of the play.

'My thought — and I want to know how it strikes you all — is to underline Shakespeare's concepts in the way he'd do it himself if he was here. Example in Act 3 where Queen Constance goes into a frenzy, Queen Constance is frenzied in Act 3. Now there I'm bringing a crowd of lunatics on, a whole circle of ravers, everyone tearing their hair, cracked laughter, everyone that is except Constance herself who stays quite, quite calm. I'll block that out as soon as Sal gets here. Emphasising the fact that though Constance is quite, quite mentally afflicted, politically speaking she's the only sane person

on stage. Speaking politically, of course. Then this Prince Henry, King John's son, who comes on at the end and inherits the crown, we haven't cast him yet, how old is he supposed to be?'

'About ten,' said the assistant stage manager.

'Yes, well, my thought here was to have him played as an old, old man, tottering on, scarcely capable, with a stick. This old, old man of ten who walks with a stick. I'm asking the casting director to find me an old, old actor. We'll mime the stick, no props, or wait, the stick to be the only prop in the entire play. I trust you're taking all this down. Young Prince Henry to be senile while everyone else on stage makes grotesquely childish gestures. All the young to be old and the old to be very, very young. King John himself to be sucking at a bottle of milk. Mime the milk.'

Neither William Beardless nor Boney took much notice of this, as they believed from past experience that Ed would settle down after an hour or so and talk fairly sensibly, though only fairly. The younger actors were keen to join in, one of them suggesting that at the line 'Why here I walk in the black brow of night' all the lights should be at full strength. But Ed couldn't bear anyone to stand aloof.

'What's your reaction, Boney and William, to actualising some of the scenes that are only talked about in the text? Example, there's this description of a monk who's tasted

poisoned food, a resolved villain, etcetera, whose bowels suddenly burst out ... that would get a slight laugh.'

'Yes, and you could mime the bowels,' said Boney.

Mattie was already doing so. This drew attention to him, and Voysey spun round in his direction.

'We're having you in a sailor suit, you know,' he told him. 'To set your character the moment you come on — a silent victim — silent — a child forced by the adult world into the uniform of a killer. But with a 1910-ish broad straw hat to suggest innocence — those long bits of ribbon ... or no, a sailor hat with white lettering on the front ... SS TITANIC ...'

'That'll be lost by the third row of the stalls,' said the ASM. Ed dropped the subject, fearing to lose his players' attention, for he knew that none of them had the slightest interest in any costume except their own.

Although *King John's* production manager went down and harangued the caretaker, asking how the Scout Movement, or any form of Youth, could continue in such conditions, the hall remained damp and cold. About this the players, true to their vagabond heritage, complained very little. It could be said they gloried in it. The greater the squalor, the greater the miracle. Ed asked them to be off book as soon as possible, and began to place one or two scenes.

At the first glance Mattie had set his sights on William Beardless, aware that the actor was aware of him, and that something might be made out of it. But the torture scene had to be run through with Boney. On the subject of props Ed had given way sufficiently to allow the ASM to devise battery-powered red-hot pincers which, with a little fiddling, would gradually fade to black. They were not anything like right yet and had been sent back to the workshop, sweet Jesus grant they'd be ready for the opening. Meanwhile Boney, empty-handed but wearing round his shoulders something that looked like a pram-cover, to get the feel of a cloak, declaimed to Ed and to the empty chairs.

> Heat me these irons hot, and look thou stand
> Within the arras. When I strike my foot
> Upon the bosom of the ground, rush forth
> And bind the boy which you shall find with me
> Fast to the chair. Be . . . be . . .

'I don't want too much naturalism, Boney. You needn't pretend you don't know what's coming next.'

'I don't know what's coming next.'

'I mean the apparent searching for the next phrase. It can be very effective, of course.'

'I *am* searching for the next phrase,' said Boney. 'I've always been a rotten study. The reason is that quite often

I've been drinking too much the night before, and that may well be the case now.'

'Shall I give you the line, Mr Lewis?' Mattie piped with calculated brightness. '"Uncleanly scruples! Fear you not! Look to't!"'

It was not the right line and Mattie only gave it — since he loved words — to roll the juicy syllables round his tongue.

'You were asking for suggestions,' said Boney. 'How would it be if we varied this scene? Instead of being touched with mercy and putting away my vile intent, I could knock the little prince down and stamp on him.'

Ed Voysey drew him aside.

'I know, I know, the little shits are unbearable, they're death, any scene with these little shits is death . . . You know, one of the reasons I asked you to play Hubert is because you've got that marvellous quality of, well, I can't call it anything but tolerance. I call it tolerance. And William told me that you didn't mind kids.'

'I think that must have been true once. I've got three of my own somewhere. It's just that it's so long since I saw an ordinary child.'

'When this one's finished his eight weeks I'm getting another one from Freddie,' the director pleaded.

'I'm sure the supply is endless.'

'I've auditioned the new one and he's very good. If I can get him to use some more voice he'll be very good,

quite extraordinary. Mattie's going to make an effect, yes, but this new one's extraordinary.'

'All that interests me is whether he's going to try to give me my lines.'

'Perhaps you'll know them by then.' Ed regretted saying this, as he made it a rule never to score off the cast. But Boney smiled. It was quite true that he was tolerant. He had forgiven his own shortcomings, and didn't mind them being referred to. Presumably he had also forgiven something which no one spoke about to his face, the waste of his talent. To Boney a certain level of performance came so readily, and earned him such a reasonable living, that he might have felt it ungrateful to Providence to work harder. He had none of the actor's natural craving for a long part, no matter how unintelligible. His nickname came from his appearance as Napoleon, in one of the numerous film versions of *War and Peace*, his only line being 'Eez eet steel snowing?' How much he had earned per word in that movie was still discussed. At forty-three, Boney was not likely to start making an effort now.

But, if irredeemable, he was also, in his way, reliable. When the time came he would be word perfect, just as certainly as the party after the show would never quite get going without him, and just as he would have parked his large old Citroen in a place unacceptable to the police. And even now he braced himself to

the task, correcting his expression of extreme distaste at Mattie's

I would to heaven
I were your son, so you would love me, Hubert . . .

to something suitable — duty struggling with pity — for

If I talk to him, with his innocent prate
He will awake my mercy . . .

'Yes, dear, yes, dears, it's very good, I'm touched,' Ed called from the back.

'Innocent Prate, there's a good name for a character,' Boney muttered. 'Let's say a blue film. How Mercy awaked and the nasty shock Innocent Prate gave her.'

Voysey told them to take a break. After that he wanted to go through the whole scene again.

10

MATTIE knew that when Jonathan took over Prince Arthur he would do it very much better. About this he was jealous, but not resentful. Jealousy is in the very air that actors breathe, they can hardly dispense with it, and it is also natural to children. But Mattie, although he often wished that Jonathan was dead, loved him even more intensely for the success he was going to have. He would, however, have liked to control it completely, as with a mechanical toy of his own making. At every opportunity he gave advice. Jonathan mustn't mind Boney, still less William, who was a soft touch, he'd have to be careful about his pauses, because Ed didn't like long ones, he ought to ask Costumes for something a bit more important than a straw hat, or, being so short, he might look bloody silly. Mattie's father, whose business had called him away at the moment to Zurich, would be back by the time Jonathan went into the show and after the first night he would take them both to Blooms for supper, anything they liked, no expense spared.

Oddly enough, however, Mattie gave no advice at all

on the most spectacular of his three scenes, the Jump, consisting of Arthur's attempt to escape from gaol and the fatal fall on to hard ground.

> The wall is high, and yet will I leap down.
> I am afraid, and yet I'll venture it.
> If I get down, and do not break my limbs
> I'll find a thousand shifts to get away.
> As good to die and go as die and stay . . .
> O me! My uncle's spirit is in these stones!
> Heaven take my soul, and England keep my bones!

The truth was that at rehearsals, which had now moved into the theatre, the Jump was not going particularly well. Mattie was agile, but not courageous, and Ed Voysey had to lower the prison wall to an unconvincing height, really asking, as Boney pointed out, for a mass walkout by the inmates. The scene had to be rehearsed every morning by an instructor to meet safety regulations, and at his suggestion the stage was covered with foam rubber to such a depth that Mattie was liable to bounce comfortably off the pitiless ground before expiring. Ed was now thinking in terms of a filmed back projection in slow motion, with the prince falling like a wounded bird through the summer air. But there was no time for filming, no money either. And Mattie had after all many good points, playing Arthur with a sort of

cheerful self-confidence, as though he was taking in the whole array of kings, queens, lords and torturers with his show of innocence. This largely made up for his feeble performance in his death scene. And Mattie, unwilling to admit the feebleness, avoided talking about it.

But Jonathan, as he listened peaceably, wanted to consult somebody, before he went into rehearsal himself, about the Jump — someone, that is, apart from his Shakespeare coach. This coach, though as old or even older than Old Ernest, was meticulous, beloved and respected, invaluable to Freddie. His methods were well-tried. Many successful actors must still remember the bitter taste of painted wood as they were made to repeat their lines clearly with a pencil between their teeth. Jonathan was glad to oblige, particularly in the matter of the pencil. But when he was told to imagine himself, let us say, as a young prince, his attention withdrew. He felt the compulsion to pretend to be someone else, but in quite a different manner. Jonathan was born to be one of those actors who work from the outside inwards. To them, the surface is not super-ficial. He didn't want to know what it felt like to be desperate enough to jump from a wall; he wanted to know what someone looked like when they did. From a walk, from a hesitation, from a nervous gesture, from breathing and silence, actors of Jonathan's sort under-stand the human predicament. Jonathan, for instance,

knew what frustration was from watching Carroll watch Hannah.

Since he was not old enough to explain the process to himself he did not attempt to defend it to others. However, he wanted to consult Carroll, in whom, since the day of the Master's visit, he had put absolute trust. The experience of being singled out in any way was quite new to Carroll and he turned it over and over in his mind before he could get used to it.

Jonathan asked him whether he had ever seen anybody jump from a height because he'd do anything to escape? How cats do it he knew very well, as he was able to observe two of them in the warehouse opposite the class-room windows. A good deal of calculation and minute shifting from foot to foot is undertaken by a cat before it springs. But what about human beings? Had Sir ever had to jump like that? After one of his customary pauses Carroll replied that it so happened that he had.

The two of them were sitting in Tito's Cafe, drinking an unpleasant pinkish liquid, recommended by Jonathan.

When Carroll was still at primary school, he and three other boys from his class had hitched a lift on the back of a lorry carrying straw bales. They had climbed on while the driver was in the Men's in a layby, and knowing well what he was like they agreed to jump off just as he slowed down before the level crossing. Carroll had jumped third and landed badly.

He felt his ankle go; they told him later it was a Potts fracture.

'Well, how did your friends jump?' Jonathan asked. 'Did they hold their arms out sideways to steady themselves, or did they put them forward, like diving?'

'You couldn't call them friends, exactly,' said Carroll. 'They were just boys in my class. And it was only the last one, Jimmy Gorman, that I saw from below, from where I was lying on the grass verge.'

'How did he have his arms?'

'Straight down by his sides.'

'I suppose he didn't have a hat on?'

'None of us had hats, but James Gorman had a school cap on, where it was from I don't know, because we hadn't caps at the primary. As he jumped he threw his head back in fright and the cap went spinning away.'

'Which came to the ground first?'

'First Jimmy, then the cap,' Carroll replied. 'I lay there on the grass and looked up at him, and he landed just as badly as I did, and there we were both in considerable pain, and all he did was to keep searching and asking for his cap.'

'Why did he?'

'That would be the effect of shock. When you have someone in shock they commonly fix on a very trivial detail, just to take their mind off the more important thing. What I'm telling you now is an example. There

were Jimmy and I in two sorts of trouble, the other two boys had split and there we were neither of us able to walk and next thing the lorry was held up at the crossing and the driver looked round and saw us. All this time Jimmy was crying and calling out to me, "Pierce, did you see my cap?"'

Carroll sighed, feeling that at least he was giving some kind of instruction, and hoping to be asked for more. But Jonathan, sitting opposite him, had taken in quite enough. He saw, in the form of a brightly lit frame surrounded by darkness, not the lorry and the cap, but *Enter Arthur on the walls*. The jump ought to be from as high as the director and safety would allow, and the straw hat drifted down slowly, turning once or twice, and seeming until it landed to be still alive, after the prince was already dead.

He shook himself like a terrier, and interrupted Carroll, who was still droning on, by asking him whether he'd like to see a fortune-teller. This consisted of a sheet of paper torn from an exercise book and folded into a shape with sixteen corners, any of which could be pulled out to show what was written on it. Probably very few people go through any kind of schooldays in this country without making a fortune-teller, but it was a disconcerting and even touching thing to see how very few of these commonplace games the Temple children knew.

Anxious to be going — Hannah would be just about

back from her lunch break and they might exchange a few remarks — Carroll pulled out one corner of the creased and dirty paper. The words, in Jonathan's disgraceful handwriting, were YOU WANT IT BUT DOES SHE?

'That could hardly be termed a fortune,' he said. 'There's no element of prediction in it.'

Without troubling to explain this in easier terms, he got up and paid for the milk shakes, whose price was shouted by Tito in the depths to his stern wife at the cash. So the feelings that were precious to him, and which he thought he had managed to conceal so well, were being made game of. The girls, doubtless, had had a hand in it. Yet Jonathan's face was sober. Probably he was trying to be helpful.

Carroll did not ask to open the fortune-teller and try his luck again, suspecting that the same thing was written on each corner.

11

Unwin, the enslaved accountant, always believed that Miss Blewett, being oppressed like himself, ought to take his part. She ought, for example, to encourage Joseph Blatt's prospects of investment. And, in particular, she should try to check the unbridled gaiety in the office, where, with two boys booked for *King John*, several more in *Dombey & Son*, three in *Peter Pan* and a number of the girls taken on as Snowflakes in the *Nutcracker*, nothing now seemed impossible. Even Joybelle was in pantomime at Morecambe Bay. She rang up to say that she was the third Little Peach in the Fruit Scene. But Christmas, both Blatt and Unwin pointed out to the Bluebell, doesn't last, and never has done.

Miss Blewett, however, had not forgiven Blatt for dosing little Jonathan, and considered that he and Unwin were no better than conspirators. Furthermore she herself was a creature of tears and laughter — much worse, in that way, than Freddie, Unwin thought, though at least she wasn't in charge of the administrative decisions. He repeated that the present favourable situation couldn't

last; in reply Freddie informed him that Noël Coward's parting message, Play It Large, had come back to her since then as a Word. She had understood this as meaning that the staff (though of course their actual salaries could not be raised) should be treated more generously. By temperament, in fact, she was generous enough, as long as she kept the upper hand. Giving pleased her, even if not quite as much as taking.

She sent for Hannah and told her that she would be wanted at the Nonesuch Theatre. Rehearsals for *King John* had now moved in, and under the Greater London Council's regulations Mattie, if he worked there all day, was obliged to have three hours' education a day from a tutor on the spot. It was the prospect, in fact the promise, of this which induced Hannah against her better judgement to take the job, but this was the first time it had come to anything.

As she went to fetch her coat she met Carroll, carrying the large brass handbell which was rung to start and end the classes. Round the rim was the inscription: '"The iron tongue of midnight hath toll'd twelve": *to Freddie, in gratitude from her little Fairy Folk: Midsummer Night's Dream, 1927.*' Carroll handled it with extreme caution, as the least sound from the clapper at the wrong time would provoke disorder, if not a stampede.

'Are you off already, Hannah? Have you a headache?'

Carroll had been conditioned by his large family to

believe that women were weaker than men.

'Perhaps you'd like me to see you to the bus stop,' he added. 'Or I could see you back, if you prefer.'

'Pierce, the classes. There's very few left in them, could you take them all together? I'm going down to the Nonesuch to see to Mattie's education.'

'All day, Hannah?'

'You're free to laugh at me, if my sisters were here they'd feel the same, but it's a great thing for me to be going backstage. I came to London only for that, really.'

Carroll did not comment on this, but simply repeated: 'You'll be gone all day?'

He held out the bright coat for her to put it on, venturing: 'You look grand in that coat, Hannah.' She wore it every day and that was really his point, although he hardly expected her to grasp it. From the window he saw her running off in the direction of the Strand, almost running, anyway.

The Nonesuch is just off the Strand, on the site of a medieval royal palace. The stage door is in Wellington Street, the pit and gallery entrance at the bottom of Catherine Street, and the theatre covers part of the triangular site between them. Built, or rather rebuilt for the third time in 1869, just in time for Charles Dickens to visit it and to think well of a couple of farces there,

it has an attractive, frowsty facade, painted in plum-red, white and gold, somewhere between a Victorian public house and a Victorian Venetian church. It has never had a famous or even a very prosperous period, no great managements, not even a great fire, but in spite of this and in spite of the cramped conditions, most actors have a kind word for the Nonesuch.

Hannah had been there only once, with the Bluebell, to see a comedy which had just come off. Now, turning out of the Strand into Wellington Street to find the stage door, she felt in a different and inferior position, like a governess at the family dinner party. This wouldn't do. She took herself to task. She had been looking forward ever since she came to London to the experience of going backstage.

'I'd like to see whoever is in charge of the children, that is, the child here, that's to say, Matthew Stewart.'

'Are you his education?' the doorman asked.

Hannah nodded. She had with her a card identifying herself as employed by the Temple Theatrical School, but was not asked to show it. The truth is, she told herself, you'd be known as a teacher if you were standing naked in the middle of the Gobi desert. If a human being came along he'd recognise you at once for a teacher and know you were harmless. In the case of us females, it's perhaps something to do with the kind of capacious

bag we have to carry. Naked or not, we'd never give that up.

The doorkeeper returned to his *Racing Standard*. It was flattering, however, that he expected her to know where to go and what to do next.

At last she was inside a stage door. Sick of reproving herself, didn't her mother do enough of that, she allowed herself to feel admitted to a secret society. She stood between the firebuckets and a pile of boxes which might have told her, even on their own, that she was backstage, for no one could remember who had brought them or what for and it was no one's business to take them away. And it was here that the profession planned and conducted its loving war with the public, the friendly aliens on the other side of the curtain. She was behind the lines, where she'd always wanted to be.

The corridor looked as though it had never been repainted because someone took a pride in its bleakness. The cold kept the dank smell somewhat at bay. Out of a sort of cupboard, or pantry, a shape emerged with a broom.

'Have you seen Mattie Stewart?' Hannah asked, knowing that Mattie only had to be in any place for a day to make himself known, however unfavourably, to everyone.

The cleaner was a West Indian, tolerant of the useless anxiety of others.

'He won't be where he's supposed to be, love.'

Hannah did not care to go back to the doorkeeper. She had the kind of temperament which always goes forward rather than back. Surely someone would be wandering about, that was what corridors were for, and then she could find out when Mattie would be free for a lesson. She turned left, away from a distant noise of echoing voices and interrupted music, and began to climb a flight of stairs. This was from habit rather than reason, because when the Bluebell couldn't get passes they always tried for the back of the upper circle. On the first landing, however, marked in gilt letters, and with a pointing hand, as B dressing rooms – but these were much too good for Mattie and she'd better go on up – she met, as she had expected, someone wandering. It was the wreck of a blue-eyed grey-haired man, just able to pull himself together enough to give her a well-worn smile.

'Please could you help me?' she asked.

'Since you say "please".'

'I'm looking for Matthew Stewart. I want to give him a lesson.'

'Congratulations, my dear.'

'I'm his education,' Hannah persisted. 'But I don't know where to start looking for him or where to find a room to teach him in . . . I think you must be one of the cast?'

'I'm Boney Lewis,' he said, pausing, as every actor must, in no matter what state of decay, to see if the name was recognised. Nothing. She continued to look up at him. 'If you want Mattie, though, you've come to the right place. The rumour is that he feels ill and he's been sent to lie down in my dressing-room. In all honesty, the dressing-room I share. B1, the first one you come to, which, to my mind, is not a sufficient reason for turning it into the juveniles' sick room.'

'Do you know what's wrong with him?'

Boney threw up his hands in a lavish gesture.

'My dear.'

With the shadow of a bow he passed her and began to negotiate the stairs down. It was the first time Hannah had ever talked to an actor, as you might to an ordinary fellow, and she was not disappointed. He had never yet given — though Hannah could not know this — a disappointing performance.

She rattled at the door of B1 and then sharply opened it, meeting a smell like a chemist's shop, cold cream and something else. The light was on and unexpectedly she caught sight of herself in the glass opposite, a disconcerting moment always, for then it seems as if your reflection has been waiting for you. She looked pink-faced and tidy, and, it struck her now, absurdly determined.

Mattie was lying on a narrow seat or sofa, wrapped in

a military greatcoat. The slight groan he gave might or might not be deliberate. With his long lashes fluttering on his pallid cheeks, he looked like one of the photographs which Italian undertakers supply for the graves of the departed.

'William . . . Mr Beardless . . . you came . . .'

'Who were you expecting, Mattie?' asked Hannah sharply.

He glimmered at her through the fringe of his lashes.

'Miss . . .', he said faintly.

In class or out of it, Mattie had never called her anything but 'Miss Graves', or once or twice 'Hannah', when excitement had got the better of him. It was Gianni who had called her 'Miss' and Hannah took note that Mattie was giving a fair imitation of Gianni's voice; he was for the time being a child from a poor home, dogged now by ill fortune and scarcely able to manage a weak word or a smile.

She put down the bag of books she had brought and looked round for somewhere to hang her raincoat. Every wall fluttered with bits of paper, old messages, old telegrams, good luck notes, notices from the Actors' Church Union, newspaper cuttings, flags, mascots and one or two ex-votos in the shape of silver arms and legs. What would poor Pierce do in here, she thought. It would drive him mad within ten minutes.

'Aren't you going to ask what's wrong with me, Miss?'

'I expect you've told everyone else in the place.' But she was moved by the curious atmosphere of the dressing-room, the air of expectancy and of all its past expectancies, disappointments perhaps, reduced now to the withered telegrams, two or three deep.

'Well, what's wrong with you, Mattie?' she asked at length.

Mattie lay back and relaxed, his power recognised.

'I've seen it, Miss.'

He pulled the overcoat round him with trembling fingers.

'Don't you want to know what I've seen?'

'Well, what did you see?'

It appeared that he had caught sight of the ghost of an old-timer — that was how Mattie described him — who was known to haunt the theatre on Thursday nights. The ghost was said to be that of a Victorian music-hall comic, who in his last days went over the border of sanity and applied at one theatre after another, begging to play Richard III.

'He tries to go out where the box-office is now, but he can't get through,' Mattie went on. 'All that part's been built on since ... Don't you want to know what it looked like?'

'What did it look like?'

'It might just have been an ordinary sort of old man going by, that's why I got this shock, Miss. Still with his make-up on, eyebrows like this, honest, Miss, he seemed to be beckoning me.'

'No, he didn't, Mattie.'

'You don't know the gestures these old men make, Miss. At all events he wasn't natural.'

'Perhaps that was just as well.'

'Tell you something, I'm old enough not to get over a thing like this. A thing like this could make its mark on me for as long as it takes.'

Hannah felt that she was not getting the better of Mattie. She remembered with self-reproach that Gianni had told her at least half a truth, and she had not believed him. She struggled, however, to keep her viewpoint correct. Mattie was simply trying to draw attention to himself. And this came back to her now as one of the most reprehended faults of her own childhood: don't show off, don't make a holy show of yourself, don't keep thinking about your looks, nobody's going to notice you anyway, but it could hardly be so much of a fault if you hoped, as Mattie did, to make your living by it.

She made him sit up and gave him a French vocabulary and a pencil. He accepted them readily enough, but it was all quite hopeless, she'd better come back another day and find someone, the assistant house manager probably, who would tell her exactly where she ought

to go on these occasions. It was only a kind of willing bemusement which had led her up to the dressing-room in the first place.

While Mattie, still in character, copied out a few weak words, Hannah tried to make room for her things on a row of iron pegs above his head. Three of the pegs were already taken up by a tweed overcoat, a Donegal tweed so fine that she felt like stroking it, with a pale silk lining, the sort of coat that would always look good anywhere.

'That's Mr Lewis's coat', said Mattie faintly.

Hannah was surprised. From the meeting on the stairs she would have thought him only just about able to make ends meet. Perhaps this garment, which was never likely to show its age, was all he had left from more prosperous days. And the ready though inconvenient sympathy welled up. She saw Boney as the needy Colline in *La Bohème*, obliged to sing a farewell to his favourite overcoat. Still he was in work now, and *King John* might have a good run. She checked herself, seeming to hear her mother's voice with painful clearness: 'Who is this fellow, anyway, some kind of actor? Are you mad, Hannah, or what?' She was getting nowhere with her lesson, and after all it was as a teacher she was paid — and now there was someone coming in, not much privacy here it seemed. The door opened with a large gesture, and Boney made his entrance.

'Is he in pain?' he asked, glancing towards the sofa.

'Oh, no, I don't think so.'

'Pity.'

'You should think what you're saying,' cried Hannah, too indignant to care whether she sounded like a schoolteacher or not.

'No emotion can be so pure as the hatred you feel for a child.'

Mattie put down his pencil and looked at Boney with feigned surprise.

'You're not drunk, Mr Lewis.'

'You're not ill,' said Boney.

They understood each other perfectly. And after all they were in the same profession. Hannah felt distressed. Of one of them she wondered, what will he grow into? and of the other, what was he once?

'I've just started Matthew's education,' she said, 'I'm aware that this is your dressing-room, or half of it is, but I should be very grateful if I could have the use of it for a little longer.'

'The child is wanted on stage,' Boney replied. 'They're going to rehearse the carry in Act 4. Go, bear him in thine arms, From forth this morsel of dead royalty The life is fled.'

'I haven't had a call,' said Mattie doubtfully.

But, as though on cue, the intercom in the corner, one of the very few new pieces of equipment at the Nonesuch, cleared its throat; a call for Prince Arthur.

Hannah had expected the child to spring up at once, and as he slowly uncurled, the idea seized her that he might really be ill, but he only said:

'I hope Mr Beardless isn't annoyed with me. I'm afraid I made him miss an entrance this morning.'

'So that's why you're hiding in my dressing-room,' said Boney.

Hannah didn't at all mind being left alone to talk to an actor, but why did she have to begin by saying, 'You're the first actor I've met,' a needless remark, just as needless as what she'd said to poor Pierce about those sheets of hers. And then, although she'd explained twice already, she found herself beginning on how she was afraid she wasn't much of an advertisement for the Temple School, because she'd only just arrived and got started and now she supposed there was nothing else for it but to go back again.

'What's your name?' asked Boney, enormous on the narrow sofa.

'Hannah Graves.'

'Well, Hannah, whatever mystery there may be about your movements, there is none about mine. Three-quarters of an actor's life is spent waiting for something.'

His voice was a rich bass, but now he continued on a note half way between grumbling and keening:

'They tell me that I've got to speak in a higher register, so that King John will come out as the deepest voice in

the play. Just to raise my pitch a fraction, to squeak
and gibber, doubtless they want to turn me into a boy
soprano, just a little operation, just a little snip with a
pair of scissors, ensuring me a job for life, the Papal choir,
the Aldeburgh Festival, a Japanese salesman at the Motor
Show . . .'

'I think you're exaggerating,' Hannah said. Boney was
not disconcerted.

'So, my dear, you want to meet actors. Well, that
can't be done. They can't be met. They don't make good
friends.'

'I think it's a very difficult profession.' But that was
absurd. No one could possibly have looked more at their
ease, or less prepared to make any kind of effort, than
Boney. She tried again. 'I've heard it said that you can't
be a public and a private success at the same time.'

'They're right. I'm not.'

As she leaned over him to get her bag and raincoat
down from the iron pegs Boney stretched out an arm
and with the ease of long habit grasped her round the
thighs and squeezed her energetically.

'Don't let me excite you too much,' he muttered with
closed eyes. 'I'll have a call in a few minutes.'

'Is that what you came back here for?' Hannah asked,
interested.

'No, no, I came back because I thought you might be
giving a maths lesson . . . I wanted just to sit and listen

to it ... I came back specially for that ... I'm quite uneducated, I've had no chance of a decent education, no chance, none, I need everything explained to me ...'

She might, perhaps, have explained that he had shown neither kindness nor responsibility towards Mattie, and that it was time for her to be getting back, but it was delightful to Hannah not to have to worry about such things, at least for the time being, and in any case they might sound better when he had let go of her, she thought.

Sitting half way down the stalls, in N22, from which supposedly very little could be heard and which therefore served as a test for all the others, Ed Voysey was by now in a very nervous condition. William Beardless, who preferred to discuss each point alone with the director, sat beside him, in N23. William was not an easy person to deal with. It was cruelty, nothing less than cruelty, to be asked to deal with him. With his high reputation, distinctive style, and large following, he occupied his own chosen ground, but insecurely, always on the watch for infringements. Ed felt obliged to listen to him, although one part of his mind was calculating how long one could do this without becoming insane, and everything they said was interrupted by snatches of taped music from the stage, where the cast were waiting to rehearse the carry. This music was disturbing in itself, being in fact *Land of*

Hope and Glory played backwards, the Edwardian dream, as Ed saw it, in reverse.

'What is it, William, what ails you, dear William?'

'I just want to query the passage in Act Four where I, where King John hears of his mother's death. The messenger has six lines there to tell me that my noble mother's dead, her ears are stopt with dust, and all I say in reply is: "What! Mother dead!"'

'Well —'

'"What! Mother dead!" would seem inadequate, I think, even if said — and mothers must die there, as elsewhere — in Surbiton or Tonbridge.'

'Surely you've got some more lines, William, some more to say at that point, some more lines there.'

'You cut them yesterday', said the assistant stage manager, from two rows back.

The greatest of actors would rather be cheated of a pound of flesh and blood than of even half of one of his lines; if he didn't feel this, he would not be an actor. Moved by his principal's anguish, Ed yielded, and restored all that he had removed. Beardless, with an irritating smile of Christian forgiveness, received the lines back from his director's hands. Ed could now go ahead with the run-through for the new carry.

Shakespeare had slipped up badly, in Ed Voysey's view, in leaving Arthur, the morsel of dead royalty, lying on the stage for over a hundred lines while various

lords discussed what to do next. Better to cut every-
thing, except the moment where Hubert enters and
is wrongly accused of murder. Boney would have to
draw his sword there in self-defence and the flash of
light from the blade should tell all the better because
he wouldn't be wearing that conspicuous gold watch. Ed
mentioned this as a kind of joke, to lighten the tension,
or rather the lack of it, as Boney had emerged from the
dressing-rooms only after being called twice, and looking
drowsily amiable. But at the mention of his watch he
stiffened.

'I've never been on stage without it.'

All the cast looked as though Voysey, whether he
had ever worked with Boney before or not, should have
known this.

'Well, if it's helpful, if it seems to help . . .'

'My father used it when he was starter at the Chepstow
Races. Have you ever heard of a late start there?'

'My dear, if it's brought you luck, there's absol-
utely nothing more to say . . . Has it brought you
luck?'

'No,' said Boney, But I don't know what things would
be like without it.'

For the carry, to which he now hurried on, Ed now
had in mind a kind of funeral procession, the little dead
prince to be borne along with one arm hanging limply
down, when the audience left the theatre they'd still

see that arm and hand in their mind's eye — the hand would be very white, very heavily made up — he'd have to be carried right at the audience, perhaps right into the audience and up and around the back of the dress circle — could they just walk that?

'An idea,' said Boney, 'we might drag him along by the feet.'

Mattie, who was now blissfully the centre of attention, cast a piteous glance at his director.

'Please, Mr Voysey, I think I should feel safer if Mr Beardless was on stage.'

Ed tried for an indulgent smile, feeling no answer was necessary, but William immediately leant forward.

'Well, Ed, why not? The king can't actually be a witness of the death, of course, that's counter to the whole plot, but I could appear rather high up as a disembodied presence, say stage right, brooding quietly over the whole pitiful scene.'

And Mattie enquired, in his lightest treble tones, whether, if he had to carry on without Mr Beardless' protection, he might chew gum in order to calm himself during the carry. 'Spearmint, Mr Voysey!' he thrilled. A chewing morsel of dead royalty. Ed got to his feet, and asserting himself at last told them to run through the scene twice, and then break.

Out of these setbacks, more, surely, than any director should reasonably be called on to bear, the proud illusion

had to arise. The time was getting short. But he knew that actors are at their most perverse and bloody-minded only when things are going well.

12

HANNAH did not need another letter from her mother, asking her whether she had come to her senses, to know that she hadn't. She owed it to herself, however, to put her thoughts in order, at least to the extent that her room was in order, that was, good enough to pass.

To begin with, she earned her own living and was answerable to nobody, except to her own sense of what was right. No need to give an account of herself to her family, or to the nuns, or to her first-year tutor at Queen's who had been a very, very dear friend of an old friend of her mother's, and yet it seemed to have taken her a long time to realise this and even now she had to remind herself of it for fear it should slip her memory. It was partly in order to prove it to herself (though mainly because she was soft about him and even truly fond of him) that in her second year she had taken to going out with John Brannon and later, whenever they could afford it, going away with him. Just for the first time they had saved to go to London, to the Regent Palace, and back came the embarrassment, hot as

fire, which she had felt when she had got out of her bath and found there wasn't a towel, and hadn't liked to call out for fear Johnny wasn't in the room and some waiter or other might come, and had been reduced to drying herself with her pale blue linen dress, which had done the job well enough but had looked like a dishrag afterwards. The agony of the missing towel and the dress — which had been her best one, after all, seven guineas from My Fair Lady in Belfast and only bought because they were going to a London theatre — had stayed with her longer than the memory of Johnny's love-making or even Johnny himself. He couldn't be expected to write often from the States, where he went to finish his medical training, and it was a relief not to have to answer when she could think of less and less to say. Her mother, however, still dwelt unsuspectingly on that nice Brannon boy you were so great with at one time, they say he's getting on very well over there and in any case a doctor never starves.

It was *Romeo and Juliet* that they'd gone to together, at the Old Vic. Hannah, in her damp, wrinkled linen dress had watched Juliet die. It had been grand, really, they'd had a grand time while it lasted. But she believed, from experience, that people are divided into choosers and chosen, and that only by continuous effort can you struggle from one class to the other. She wanted to choose. She had chosen not to follow Johnny and not to help him get on well in Galveston, Texas.

After the rehearsal of *King John* Boney had taken her backstage just for a few moments. The lighting designer had arrived for a run-through, and she stood in the darkness cast by the back of the set and vanishing upwards into the high vaulting shadows above. Boney showed her the prompt corner and switchboard, and engaged her with a series of tales — how Larry Olivier had been shot through the leg with an arrow in *Henry V*, how he himself had caught his sword in the overhead wiring and been shocked rigid, how William Beardless, playing Peer Gynt, had been struck by the Troll-King's tail and had fallen weeping into the front row of the stalls — tales of danger and disaster, and other gentler ones of misunderstanding. When she left he had come as far as the corner of Wellington Street, where he embraced her shapelessly. 'Hannah, whose hair shadows her neck, and her eyes are clear.' She had decided, not really then because she had thought of it much earlier, that she would like to train as an assistant stage manager. Practical sense was needed there, surely, as much as in teaching. Her family would think her mad to break her career and her pension, probably her aunts would say she ought to be committed, but she would be working on the edge of the theatre's lighted world.

It was a strange thing, if you came to think of it, that both her family and Pierce Carroll's had once been as dead against the stage as they well could be. The Carroll

grandparents had been black Protestants and had thought the theatre a place of sin, while her own grandfather had been a Mayo man who'd come up to Dublin on a special train to shout down the first night of *The Playboy of the Western World* at the Abbey because it was known that the play was insulting to Irish womanhood. That had been in 1907 and it was his one and only outing to any theatre. She had seen the newspaper cutting he preserved for so long — *House Disorderly as Comedy Resumes: Mr Yeats Greeted with 'Get Off, You Bloody Fraud!'* And for the matter of that it was grandfather's one and only mention in any newspaper, and even then, not by name.

She didn't know why Pierce should have come into her mind at this point; now that he was there she had the familiar sensation of pity, but also of inferiority. There was you had to admit it a stubborn incorruptible intensity in Pierce, which she could never hope to come near. It made her associate him with Jonathan, but Jonathan after all was single-minded because of the talent in him which he scarcely understood himself. What ever talent could Pierce be said to have? Well, she reminded herself, there were those shelves, he was handy with the carpentry, but outside that what could he be said to do supremely well, or even well at all?

Incorruptible is not the same as unchangeable, and Pierce, in order to please her, had noticeably tried to change. Last week he had even bought two tickets for the

theatre, for *Uncle Vanya*, which was hard to get into, and it was a thousand pities that he hadn't asked her earlier because she had seen it already, and that disappointed him. She told him that he could easily get his money back by standing outside and selling them to the first people who wanted to buy them, it was always two they wanted, or failing that she'd be glad to go with him anyway. Seeing a good production twice was always worth while, you noticed little details that you'd missed the first time.

'Is that a fact?' he asked sadly.

In the end he had given the seats to old Ernest, who seemed gratified. Hannah felt that if it had been possible he would have wagged his tail.

And now this evening it was raining and Pierce wanted to see her home and shelter her with his umbrella, which was made of black cotton, the kind of thing you'd only see nowadays on a farm, or perhaps at a convent or at the Christian Brothers. Hannah disciplined herself not to mind walking along with a man who carried an umbrella like that. She knew very well what the children said about it.

Pierce suggested that they should go down one of the side streets and along the Strand; that way they'd avoid the smell of rotten cabbages. Hannah had become familiar to the point of addiction with the wafted odour of the Garden, impossible to separate from the piazza round which the great theatres stood. The lights were

up, the box-offices were open. But she very well knew that Pierce wanted to take her that way, three sides of a square, to make the walk back somewhat longer. Carroll also knew that she knew this.

He was telling her that he would have liked to train as a scientist, or at least as a drainage engineer. 'That's a life's work I should have felt satisfied with.'

'What's wrong with teaching?' Hannah replied. 'Show me anyone who doesn't remember the teacher they had when they were twelve.' An unexpected guilt possessed her.

'It's not so much that I expect to be remembered. That would be excessive.'

They turned left into the Strand, and caught a distant glimpse of the river. 'It's not raining now, Pierce,' she said. 'Put that old thing down, for pity's sake.'

He furled it slowly, respecting the great age of the stout steel ribs, and carefully aligning the folds.

'In any case, Pierce, I thought you were going to do a bit of writing? You remember you told me that. How are you getting on with it?'

'I've struck a difficulty, Hannah.'

'Oh, but doesn't everybody?'

'I don't know how many of them have the same difficulty as mine. I've discovered that I only have one subject to write about and one subject, the identical one, to think about.'

'That should make it easier, surely.'

'It makes it very painful.' Looking at the delicate colour in her face which the damp wind brought he thought, I'm an inconvenience to her. 'Well, as to teaching, then,' Hannah persisted. 'I believe you're better suited to it than you think. Jonathan has confidence in you, I know that. He takes more notice of your advice than he does of Miss Wentworth's, to my thinking. We'll go to *King John* together and see him, Pierce, later on, when Mattie comes out of the show and he goes in.'

'That's a bold child, that Mattie Stewart,' Carroll observed, and at the word 'bold', which you'd never hear used in that way in England, both of them were taken back together over many years. Without thinking she put her arm through his.

They were passing the Strand side of the Nonesuch; some of the advance photographs for *King John* were already up in the foyer and could be seen through the ornate glass doors. They stood together craning their necks and trying to make out the picture of Mattie in his sailor suit, although they could perfectly well have gone in and looked properly. It was like a game, and Hannah, relaxing, began to describe the peculiar bleakness of the backstage corridors. 'I don't know if I've mentioned a man called Boney Lewis.'

'You mentioned him twice the day before yesterday, four times yesterday, and today it was twice during the

lunch break and I think twice again when we were tidying up the classrooms. He's an actor, I take it.'

'Well yes he is. But Pierce, he hasn't had any education.'

'Where did he get his schooling, then?'

'He told me at Winchester.'

As they went forlornly down the three marble steps Boney himself appeared, tacking against the current of the crowd with an occasional sleepy genial gesture of apology, heading, evidently, for the stage door. A whiff of tweed and wine. He paused, as though confronting the long-lost.

'Pierce, this is Boney Lewis.'

Boney focused not quite successfully and said that he was glad to meet Carroll and when was he coming to see the show. Carroll was not at all glad to meet Boney, or even to have this positive proof that he existed, so he made no reply. Boney took both Hannah's hands in their knitted gloves, gave them the outline of a kiss, and lumbered on.

'They open next Thursday,' Hannah said, and then, willing to try again, 'Did you notice that overcoat of his?'

They walked on in silence. After all, she couldn't come across someone she knew perfectly well in the middle of the street and just pretend not to recognise him. It was a pity they hadn't gone straight back from the Temple,

that way they wouldn't have passed by the theatre at all. She couldn't be blamed for that, for it hadn't been her suggestion. This, of course, was true, and Hannah had behaved without design and perfectly naturally, but nature is consistently cruel.

Hannah's bed-sitter was above a small Italian grocer's which opened when the market did, and was closed by midday. It suited her admirably, and there, for the first and last time in her life, she knew what it was to be free. She took out her key to the side-door and asked Pierce would he come in for a bit, knowing that on a wet night even the transfer from outdoors to in will end an estrangement.

It was a bit of a shove, as usual, getting her door open. 'It just needs taking off its hinges and planing a little,' Pierce told her. 'No doubt the wood expands in damp weather.'

Hannah threw her things on to the bed. Well, the matches, the kettle. Thank God, she thought, that even if our faith divides us, we both belong to a nation that makes tea as soon as it gets under a roof. Poor Pierce, though, wouldn't know where to look, he wouldn't like to look at the bookshelves for fear of drawing attention to his own kindness in putting them up, and he wouldn't want to look at her clothes piled on the ironing-board in case he seemed to criticise. It wasn't confusion by any

means, just that a certain untidiness seemed to take over in her absence, like an old friend who has been asked for a long stay. Certainly the room was welcoming, with the two sagging red-cushioned wickerwork chairs. Perhaps her collection of postcards and tickets and theatre photographs was beginning to pile up a little, giving the place almost the air of a dressing-room.

She stood shaking the biscuit tin to see if any were left, and wondering about him. But Carroll was much deeper sunk in himself than she had realised, almost out of her soundings.

'If I'd been able to choose my sin, Hannah,' he said, 'I wouldn't have chosen jealousy.'

She watched the kettle, anxious that it shouldn't start whistling when he was speaking seriously.

'Well, I don't know if our seven deadly sins are the same as yours, but I don't think jealousy was one of them.'

'They call it envy, but it's all the same.'

'And you wouldn't have chosen it?'

'No.'

'Which one, then?'

'I think, sloth. I have an elder brother who still lives at home with my mother and stays in bed every day till noon.'

'What does he do for a living?'

'Just that, but he enjoys it. He lies there wrapped in his blankets, dinner is brought up to him with the

newspaper, and as I say he evidently enjoys himself. The jealous are wretched. The slothful are happy. And I'm not sure that my brother is sinning in any case. He once told me a saying of James Joyce's, that the most reprehensible moment of human delight, in as much as it has given pleasure to a human being, is good in the sight of God. Now, jealousy gives pleasure to no one.'

Hannah, warming the tea-pot, felt deeply indignant on Pierce's account. She remembered that that same James Joyce had been a lazy fellow apart from the writing, and was supposed to have declared that every room should have a bed in it. But she guarded herself from saying this and only remarked that Joyce was a Dubliner and she believed he'd been given to drinking a great deal too much.

'I believe that was so,' Carroll said quietly. After a moment he added, 'This actor, this Lewis fellow, looks as though he drinks.'

There they were again. 'Do you like your milk in first, Pierce? The nuns always said that was terribly common, and if you were properly brought up you'd let your guests help themselves.'

'There's no knowing what that might lead to. They might start helping themselves to tea as well.'

'That's true, the nuns don't know everything.' She still felt at a loss, and wished she had twenty cups to fill instead of two. 'So you think I'm doing it right, then.'

'I can't get away from the feeling that you do every-thing right.'

Hannah regretted having asked the question. It had been vanity, after all — she should have been worrying about his effort to explain himself. That must have cost him something. Indeed, he seemed to have to pay too much for everything.

'If you choose to go on the stage,' he said, still pon-dering, 'you pass your life in a series of impersonations, some of them quite unsuccessful.'

'Of course they're bound to fail sometimes.'

'They earn their money that way, and in fact they want to earn it that way. Do you know, Hannah, that causes me some astonishment. It seems to me a sufficient achievement to be an individual at all, what you might call a real person.'

'Well, Pierce, real . . .'

'I mean "real" in the sense that you might speak of a real cup of tea, meaning something up to your own standards of strength, while other cups of tea might fall short. Miss Wentworth is real in that way. On the whole in my relationships with other people I expect I fall short.'

'You don't ask for enough, Pierce! You accept so easily, you complain so little, you haven't the sense you were born with, you're an idiot! Can't you let yourself go? Didn't you let go a bit when you were young?'

'Ah my dear, I was no good at being young.'

She stood there frowning, or trying to, because she was still at an age where the skin fits the body exactly and wrinkles with difficulty. And watching her, Carroll remembered how she had been at the beginning of their short walk, full of bounding relief at the end of a hard day's work with her whole evening opening up before her in brilliance, simply because it was free time, while now he could see nothing in her face but bewildered pity.

'I'll be going when I've finished the one cup,' he said. 'Hannah, I've spoiled your evening. I deserve to be crucified for that.'

There was always something of the countryman about him, even the way he looked carefully round him now to make sure he had left nothing behind. The great umbrella, proof against the Irish rain, stood propped against her ironing-board. He was entirely absorbed in worry on her account, and once again she recognised obscurely in him some talent, raised to the point of genius. She had an unaccountable sense, too, of the freshness of air and water that were commonplace in the hard country from which both of them had come.

'You can stay if you like, Pierce,' she said. Goodness knows, he might as well as not.

'I should like to very much, Hannah.' He had been about to pick up the umbrella, but now left it where he was, and began to take off his jacket and tie.

Hannah was somewhat surprised. She had expected him to ask her whether she loved him at all or not. It was the first time he had surprised her. Then she realised that Pierce would never ask a question if he did not want to hear the answer.

13

HANNAH had never much cared for having a name chosen from the Bible. It wasn't even a saint's name. Hannah was the mother of Samuel the prophet, and for many years she had been barren, and she went to the Temple to pray that she might conceive, and the priest Eli had seen her lips moving without words and assumed that she was drunk. Of course he had realised his error and after receiving his blessing Hannah had become pregnant and borne a son, but then this son had had to be dedicated to the Lord, so that she only had the chance to see him once a year when she went up to Shiloh with a little child's coat she had made, one size larger than the year before.

Warm between sleeping and waking, Hannah sometimes found this example of industry and self-sacrifice drifting through her mind and gave thanks that she was far in time and place from Shiloh. It wasn't so much the false accusation of drunkenness that distressed her; it was the sad waiting for next year's visit. How could that ever be compensated for?

When Hannah woke that next morning she found that Pierce was gone. She felt relieved, because although it would have been consoling to wake up together she thought he might not be the sort of man with whom you could eat cornflakes (if there were any left) in these circumstances without embarrassment, and then she would have had to find her clothes and stand waiting with him, with what looked like rain set in for the day, in a situation where both speech and silence seem out of place, that is, at the bus stop. And yet last night, after all, he had not been much embarrassed.

Not a trace of him anywhere. In the kitchenette she found that he had helped himself to nothing, but had washed up and set all straight from the night before. It would be a trial to live with a fellow who liked everything as tidy as that. But the cups ranged neatly on their hooks reassured her, because they meant that Pierce had returned to the predictable.

'Where's Mr Carroll?'

'He's not come in today,' the class chanted, fixing their gaze on Hannah.

'What's the matter, is he ill?'

The opinion of the class was that he had cut his throat for love, or perhaps drowned himself. They meant no harm by this, she knew. They needed a diversion, there were so few of them here — Gianni gone, Jonathan at

an understudies' rehearsal. Alarmed in spite of herself, Hannah went down to Miss Blewett.

The Bluebell was making up the fees and commissions book in the outer office. Nice woman as she was, she couldn't help radiating the quiet satisfaction of those who know more, but have less reason to care.

'That's right, dear, he won't be in today.'

'Is he ill or what?'

'Oh, I don't think so.'

'Did he ring up at all?'

'He phoned me at four in the morning, dear. It's fortunate that I'm used to broken nights from having done so much sick-nursing in my life – pets as well, of course.'

'What did he say?'

'Just that he would have to ask for twenty-four hours' unpaid leave, because he had to go home. Some people would have pretended to have a cold, but Pierce is very straightforward. Yes, he's gone home for the day.'

'But he's from Portmoyle, fifteen miles out of Derry,' Hannah cried. She saw in her mind's eye the ploughed fields with outcrops of rock and the strand washed clean by the sea, and Pierce toiling with his suitcase along the roads where no bus ran.

'Yes, I think that was the name. He said he was taking the first ferry from Stranraer. Some of us you know don't care for flying and the difference in cost is very great. He

didn't tell me anything more, dear, I hope it's all right because it doesn't seem like him and it's so sudden.'

'I can't think of anything sudden, except accident or illness.'

'They may have won the pools.'

'But they wouldn't need him for that. If it was a bit of luck they'd had they wouldn't want him.'

Meanwhile, what about the children waiting in their classrooms? The Bluebell had a message from Miss Wentworth, who wanted Hannah to take them all together for the day, just for general subjects, you know.

'Where is she?'

And Freddie, on cue, came in.

'Is something amiss?'

She glided and loomed past Hannah to the armchair, and the two of them followed her.

'I hope you haven't frightened Mr Carroll away, dear.'

How could she guess, with such cheery malignity, at what might just possibly have happened, without the slightest hint? It was true that she had had seventy years' practice in gathering information for profit, but no one can practise the impossible.

'Miss Wentworth doesn't mean it,' the Bluebell put in. 'It was only a joke.'

'The bell will be going soon,' Hannah said. 'I hope

it's quite clear that I won't undertake to teach increased numbers for more than a day without a corresponding increase in pay.'

Freddie seemed to surge up in her chair. The light caught her array of brooches.

'You must allow an old woman to take things rather slowly. Who can have suggested that you should teach more than your fair share of pupils? It can hardly have been me, I think, dear. After all, this is the first time I've seen you this morning. And yet I don't know who's responsible for the administration here if I'm not. In time, I suppose, my memory may fail me. I don't know what everyone would feel then.'

'Deeply grateful,' said Miss Blewett, with an upward glance at the ceiling, for she had been told during her brief career in variety that whenever you have a dirty line, you should look upwards. In fact, the limits of her patience were narrower than was generally known. But Freddie did know them, and the sensation that both her auxiliaries had turned against her and were even in some kind of mild alliance filled her with a tactician's joy.

Bluebell could be left for the moment; after all, the Temple was her only means of livelihood and she was not likely at her time of life to find another job. Freddie smiled at Hannah, the smile of a kindly eccentric, priceless, indulgent and indulged.

'I hear they all liked you very much at the Nonesuch.

I think I shall really have to ask you to go there and do the tutoring more often.'

'I thought you'd got someone from outside to do it regularly. I thought it was only because she couldn't make it the other day —'

'Mrs de Bear, dear, yes, but she's suffering from a bout of deep melancholia. I'm terminating her contract.'

'Won't that make her worse?' Hannah asked.

'It will cure her. She won't be able to afford it.' Freddie turned, with a different smile, one of easy complicity, to Miss Blewett. 'You agree with me about Bruin, don't you? You've known her as long as I have.'

Miss Blewett, reconciled, nodded slightly. 'I do, but fortunately if she loses her position she can always fall back on her psychic powers. I remember there was an incident when she recovered a lost season ticket, and another one to do with a rhinestone bracelet.'

They were settling back together to talk about the unknown and despondent Mrs de Bear. Hannah tried to cling on to her sense of affront. 'Who'll be on duty here, then, if I go to the theatre more often?'

'Mr Carroll, dear. He took both the classes together the other day, you know. He didn't make any objection.'

'He may not be coming back.'

'He will be coming back.'

There was no kind of bargain; Freddie never made them. To make a bargain is not to be at an advantage.

Hannah simply went off to start the classes feeling slightly in the wrong, and as though she owed Freddie something, though she could not tell what.

When she came downstairs to set off for work the next morning, Carroll was waiting for her outside the shop door, still with his suitcase, his face whiteish-grey with fatigue. Of course he's come back, she thought, unexpectedly pleased to see him. It didn't much matter what he'd been away for, they could have a good laugh about it now. After all that's what both of them had got out from under their families for, to take life a bit more as it comes.

'I'll walk to the school with you,' he said. It was as if their lives were being played over in reverse.

'There isn't much time, Pierce, I'm going by bus this morning.'

When she'd first known him she had thought him restful to be with, and she had hoped he would be the same again now, but he was not.

'I have to talk to you, Hannah.'

'If it doesn't take too long.'

'I don't know how long it will take.'

Could there ever have been a worse place to talk things over? The Italian grocer's had formerly been a hairdresser's, and just inside the entrance where they were standing there remained a full length mirror with the

words A CUT ABOVE THE REST in gilded letters. The street was filling up now and very few of the passers-by had the strength of mind to ignore it entirely, some snatched a sideways glimpse at their reflection, some straightened and patted themselves, and all of them in doing so had to look past Hannah in a disconcerting manner, so that behind poor Pierce, standing there with his suitcase at a serious crisis in his life, she could see a procession of figures slowing down, glancing and hurrying on. Some evidently knew that the mirror was there and were relying on it to check their appearance before they went any further to face the rest of the day.

'I want you to look at this, Hannah. It's only a rough sketch, but I think you'll be able to make it out.' She took the bit of paper, praying she had it the right way up.

'Is it a map, then?'

'It's just a rough map of Muckla.'

'Is that where you've been?'

'It's the family farm near Portmoyle. I didn't bother to put all the buildings in. That's all old pasture, then the other side of the lake you've got the stony ground where there used to be sheep but now it's not fit for much. A hundred and ninety acres and my eldest brother has it with one of my cousins, but now the cousin's married a girl with a diploma from agricultural college that wants him to go in for milk and she's prepared to take on all the dairying. You can see there's nothing there for us,

no room at all. But I had a letter not long ago from my sister on the subject of our case, I've never mentioned this to you, Hannah, because I hadn't realised it would be of interest, but it's our family law suit over this land here to the south-east.'

'But you've marked that as a golf course,' Hannah said.

'But then our case sets out that these twenty-five acres have never been legally acquired by the golf course and hence they're still our property. Well they've been contesting it so long that it's treated more or less as a joke in the district, but it's always been said that if it came to anything I was to have an interest in it.'

'Is that what you went over to Portmoyle for, just to find out about that?'

'I did.'

He was so incomprehensibly hopeful, so trustful suddenly of the intentions of his family who'd always sounded mean enough to take the bits out of your mouth, that Hannah felt bemused.

'Well, if there's anything in it for you, Pierce, I'm very glad. It's just that we were a bit surprised when you went off like that leaving all your classes.'

'I don't think you've got my meaning yet, Hannah. I can't support you by teaching. Teachers have wives, of course, and they support them, but I think we should admit that most teachers are a good deal more competent

than I am. Promotion would pass me by. And while I was turning that over in my mind a scheme came to me as it were out of the blue. If there were to be two houses built on the golf course land, one for us to marry and live in and one to let, that would be a start for the two of us. I put it to the family so that they'd waste no time but begin talking it over between them at once. I didn't get an answer from them yesterday but it's my belief that anything that's wanted as much as I want this must carry everything before it. It took time mind you to convince them that there was a girl let alone a pretty one – pretty's not the word but it's one they understand – who cared enough to trust herself to me, but let that one sink in first, then let them go on to the next thing. The way I see it we could go on to build a third house on the land – I've a sketch here of how the cupboard space would be – and we could think of selling that and getting a good price for it too. You see I wouldn't want you to have to be at the farm all day talking about milk yields with the cousin's wife, no, we'd be in business on our own account. I know there's nothing you can't do well. Hannah. Wherever you are, people take notice. Just when you walk into a room, you make a difference. But then I'd thought too that when we were married we might in time grow more like each other. I've heard of such things happening. All the alterations would have to be on my side, of course.

'And then, allow me one more word, you mustn't think I'd want to put you through all the upset of a mixed marriage over there. Here in London, you know, Hannah, it's not a difficult matter.'

He paused, not for breath, but for reassurance that he had been understood. He had taken away the piece of paper from her and was folding it up and putting it away in one of his many pockets as though it constituted an agreement in itself.

'But, Pierce . . .' Hannah began.

Both of them had to work through the day in their separate classrooms, divided by the unsound partition wall for which they felt grateful. In the lunch hour they avoided each other, and meeting by chance on the way in they exchanged a smile, without any illusion that the Temple children would not have noticed anything. At four-fifteen Carroll did not wait to clear up, but Miss Blewett, encountering him outside the washrooms, looked at him archly, indeed, with her upward glance.

'Hannah has been called to the phone, dear. I daresay she won't be long.'

'I shan't be waiting for Hannah this evening,' he told her, in his flat, deliberate tone. 'It might not be appropriate, I think. You see, I asked her to marry me this morning.'

Although he could not bring himself to look at her

directly Miss Blewett caught his expression and without hesitation folded him, as he stood there in his second best homegoing tweed, in her arms.

'Oh, Pierce, Pierce . . . you must believe what I'm going to tell you . . . even Sorrow has its uses. My fiancé — I always called him that — died suddenly ten years ago, in 1952. Grief changed my appearance completely. And yet that led to the only position I've ever been offered at Harrods . . . Saturday salon model for white hair . . .'

Carroll's grief, on the other hand, had the dignity of total uselessness. But the two of them clung together. 'I'm born to be pitied,' Carroll thought. 'I must remind myself that it's better than nothing.' Yet knowing that in practice it was much worse he determined not to give up hope, not quite yet.

14

Among the strange symptoms of hopefulness in the early nineteen-sixties, of which Carroll's proposal to Hannah was perhaps one, was the foundation of a National Theatre on the South Bank of the Thames. From the very beginning this magnificence threatened the existence of the shabby tiny hopelessly outdated Old Vic, where Freddie had learned her business and Lilian Baylis had toiled to the end remarking: 'My work will kill me, but I don't see why it should be otherwise.'

During the planning stages of the National Theatre very many suggestions were made and discarded, and one of them, which of course came to Freddie's ears long before anything was put on paper, was the endowment from public funds of a National Junior Stage School, with particular attention to training in Shakespeare. Accommodation could be found in the vast complex of South Bank buildings, or purpose-built classrooms might perhaps be sited at the very edge of the river. Rigorously selected, the talented youngsters would do the new post-war Britain credit and show that the

tradition had kept true to itself. Shakespeare himself might have been pleased – but when this phrase appeared on the Committee's recommendation it was a mere coincidence, innocent of any reference to Freddie; none of the Committee had heard of her. None of them, in fact, were connected with the theatre at all. They were civil servants with responsibility for the arts, experts in educational outreach, intelligence quotient specialists, lecturers on the Jacobean drama, and speech therapists. However, the NJSS, once it got off the ground, must surely make the Temple School superfluous.

The Bluebell, coming in with the evening post, found her employer collapsed on the floor. Slowly reaching out to each side of her to ascertain her position and raising a vast wrinkled forehead, like that of the White Whale itself, but with spectacles still in place, in an attempt to see all around her, she lay at an angle of forty-five degrees to her armchair.

For a moment Miss Blewett scarcely recognised her for what she was. So much of the grey woollen stockings had never shown before.

If only Hannah had been there to help her, another woman, a woman's touch, or even Pierce, but it was after six, neither of them would be there. The evening post was, or was supposed to be, the last little task of the day.

'What's your trouble, lady?'

Of all people it was Joey Blatt, still hovering about as usual, the last kind of assistance one wanted, think of that poor wee Jonathan, still if it was going to be a matter of lifting a heavy weight . . .

'What's happening, what's the idea, what's she doing?'

'I imagine I am about to die,' Freddie declared from the floor in a full, but hollow tone.

Her fallen presence dominated the room.

'And if I am dying,' Freddie continued, turning her great grey head to fix her gaze on Miss Blewett, 'I should be deeply interested to know how you're going to manage. Don't think I've put you down for anything in my will. You can ask Unwin if you don't believe me.'

Unaccustomed allies, Blatt and Miss Blewett joined hands under the spreading shoulders. His heavy gold signet rings grated against her solitaire. 'Kindly wait till I give the signal,' he said, 'then heave together.'

Blatt's strength was surprising, and his side, in spite of his precautions, was raised much more quickly than the other, so that he looked down and across the breadth of Freddie at an impressive slope.

No, she won't die, he thought. She won't change her habits so easily. 'I'll stay and take the weight,' he directed Miss Blewett. 'You go on steering her, sideways and right, steady now, you're on the wrong lock, right hand down, nicely, that's it, we're there.'

Mass into mass, Freddie was restored, without loss of dignity, to her chair. Quite against their better judgement, they felt rewarded. It was as though she had collapsed largely, or even entirely, for their benefit.

'Is that Mr Unwin? This is Hilary Blewett . . . I'm speaking from an outside call-box . . . we had quite a fright this evening . . . it was this whole dreadful business of the National Stage School, she must have suddenly felt quite overcome, it was more like a stroke.'

'Did it put her face straight?' Unwin asked fiercely. 'Has it gone lopsided the other way?'

'I never looked. Well yes, I did look. She's exactly the same as she was before.'

'Not thinking of retiring?'

'Oh, no, she's back in her chair.'

'How did you manage?'

'I've called the doctor now. When I found her, though, Mr Blatt was there. There's a good side to all of us, you know, and it's only in trouble that we find it out.'

'Blatt's looking after his own interests, I've no doubt. Did she ask for me?'

The Bluebell hesitated. 'She said something about her will.'

'She hasn't made a will. She hasn't anything to leave anyway.'

Unwin made yet another of his unprofitable journeys to the Temple. As usual, he was expected, but unwanted. He was told that an end must be made to the pretensions of the NJSS. No need for them to be made to rue, all they had to do was to disappear quietly. They must be dealt with, that was all.

'That will require a re-assessment of our position,' Unwin said, 'and careful thought and planning.'

'I had time to think and plan, dear, while I was lying on the floor, and now it seems I'm going to have a little more. They're sending me to hospital for two days, for rest and observation.'

'She can't take on the government,' Blatt and Unwin agreed at lunchtime the next day. 'Not when it's in spending mood. You can't stop a committee once it's made up its mind to waste money. She'll just have to compromise and climb down in face of competition, the school will become a little of this, a bit of TV, a little of that. She'll be glad of an injection of capital and some sane advice. A collapse like that takes a lot out of you. She'll have to face the fact that she's a very old woman. Do you know where they've put her in this hospital? In the geriatric ward!' Their faces were those of haunted men.

So many flowers, exclaimed Miss Blewett, the only person who was allowed to visit during the forty-eight hours.

She brought sympathetic messages of all kinds, from Blatt in particular.

'I expect he's delighted,' said Freddie.

'Oh, I think you're doing him an injustice, that lovely stephanotis is from him, let me just give a little twist to the card so you can read it.'

'What are Pierce and Hannah doing?'

'They're managing quite all right, dear. The important thing is for you to rest and not to worry. Are you sure they're treating you properly?' In fact Freddie seemed to be complaining unnaturally little. She had always been quite indifferent to comfort, and the other geriatrics delighted her. But as Miss Blewett rose to go she unexpectedly smiled and murmured: 'They don't make the Ovaltine right, you know. Not as you make it.'

A very detailed history of the nineteen-sixties might mention how Freddie, once restored to the Temple School, closed the South Bank's unacceptable venture without ever leaving the office. Her fall had proved fortunate. No one, of course, knew how long she had been lying there before help came. She had not been heard to call out. But she seemed to have renewed her strength by contact with the earth, or rather with her own worn carpet.

'I shall proceed as I've always done, dear — find out who's got what I want and ask them to give it to Freddie's as a matter of conscience, which is what it

is, after all. This time it's a question of fluence.' Unwin was aware that fluence was what influence had usually been called in the old days at the Vic. 'We just want a few people with fluence,' Freddie repeated.

'What would you do with them if you had them?' said Unwin, who had a nagging feeling of treachery, all the more because he wasn't sure what he was betraying.

'I shall simply remind them, not so much that I exist, but that I need preservation. You may call it a campaign, if you like.'

'In that case it's going to cost money.'

'I don't see why. There are plenty of stamps left in the drawer.'

She intended to conduct her defence, which would be an attack at the same time, entirely through letters to *The Times*, which were then still in their golden age of influence and respect. Although she turned straight to the theatre page and never read any more of any newspaper, Freddie knew, as she did in every situation, where the power lay. And Unwin, with an odd feeling which he imagined must be relief, supposed that the idea would be quite practicable. 'You mean you might get some theatre people to write in and put your case, directors and well-loved actors and so forth.'

Freddie treated this notion with contempt. Her whole capacity for scorn seemed to have increased. She laughed, and even crowed. Protests were only effective in this

country when they were made by people who knew as little as possible about the subject. Nobody trusted an expert. Through the columns of *The Times* bishops complained about motorways, merchant bankers appealed for thatched cottages and politicians for free speech, while industrialists took up the cause of single-track railways.

'But you don't know any bankers or industrialists,' Unwin pointed out.

'I don't want them to know me. I want them to love me.'

Freddie — and perhaps it was sad that she never found scope for her talents in a wider air — could judge the moment for entire simplicity. Her plea, she saw, must be based on one point and one only: longevity. She had been particularly struck, while among the geriatrics, by their success in getting a greater share of attention even than herself by repeating that they were 89, 93 or 97. Nothing more had been necessary.

Accordingly, through the medium of the Bluebell at the upright cackling old office typewriter, Freddie wrote to the addresses of the powerful. She explained the position and implored them to use their fluence. She told them that she herself was a piece of old London who had been knocked about a bit, that Floral Street and the theatres round it had been trodden in days long past by Hogarth, Garrick and Dr

Johnson, who had said: 'I'll come no more behind your scenes, David, for the silk stockings and white bosoms of your actresses excite my amorous propensities,' that the Temple School had never closed even during the darkest hours of the Nazi onslaught and that she had almost lost count, though not quite, because an old teacher never forgets a pupil, of the number of Prince Arthurs and Young Macduffs, Lost Boys, Tiny Tims, Peaseblossoms, Cobwebs, Moths and Mustardseeds who had passed out through the Temple's plain unpretentious doorway. She quoted a line or so from Noël Coward's song about what one recalls when the twilight falls, and she asked whether it was really the intention of those who had charge of such things to destroy what was old and traditional and small and true in favour of what was official and impersonal and all that we have now come to understand by experimental – in other words very expensive at the moment and unworkable within eighteen months. Not all these remarks had too much relevance to Freddie's case. But then, she wasn't asking her correspondents to send money or raise money or even to reply, only to write to *The Times*, and in every instance she finished by appealing to them to look back through the years and remember when they first went to the play, and sat enchanted, and heard the music die away and saw their first curtain go up. And none of them, not the archbishop, not

the round-the-world small boat sailor, not the Cabinet Minister, not the Vice-Chancellor of Cambridge, not the Royal connection, could resist writing to *The Times* about their own childhood, which either because of its misery or of its ecstatic happiness was totally distinct from anyone else's.

The Editor, as Freddie had calculated, thought the subject quite suitable to run so near Christmas, and the letters began to appear at once. A headmaster recalled that his great-great-grandfather had been given an orange by David Garrick in Drury Lane and that his family still treasured one of the pips. A very distinguished general wrote: 'May an old soldier who has long since passed the Psalmist's span venture to speak on matters in which his "tongue is rusty" and his "speech unused"? Is not the vexed question (still vexed to me, at least) of the old Mountain Mule Training School, now so sadly abandoned in favour of mechanisation and "things made with hands", recalled by the present threat to "Freddie's"?' A Regius Professor of the History of the Drama, to whose attention the correspondence had been drawn, pointed out that David Garrick was notoriously mean and was unlikely to have given an orange to anybody. A controversy arose over whose memories of the Old Vic went back farthest, and some, rather surprisingly, remembered Miss Wentworth as a smiling helpful presence there in the days of Lilian Baylis. All

these letters and those that followed were printed under the title 'At Freddie's.'

Freddie's informers, on the telephone to her every night when the second house was over and the parties after the show had begun, told her that all was going well. Though almost nothing had appeared which had much bearing on her problems, she was safe. Someone had spoken to the Prime Minister. Nostalgia, on its broad current, was carrying her gently to shore. And yet Freddie, whose campaigning instincts told her that the correspondence couldn't go on much longer, was not quite satisfied. She had touched the heart of the Fluential. But shouldn't the appeal on her behalf draw to a close in the most graceful manner possible, with a letter from one of the Temple children themselves?

'I don't think I'm the right person,' said Jonathan, blinking at Carroll, who put a clean sheet of paper from the office in front of him.

'Miss Wentworth would like you to do it.'

'You know what my writing's like. It doesn't do you any credit as a teacher.'

'Well then you can take your time about it. And it will look just the same as all the others once it's printed.'

'But I never do write letters,' persisted Jonathan. 'If I want to say anything to anyone I get some money

from Miss Blewett and ring them up. I could ring up *The Times*, if you like.'

Mattie had to be applied to. Though well aware that he hadn't been asked first, he readily obliged, and presumably as the forthcoming Prince Arthur he was really the more suitable of the two. His letter, with one or two wrong spellings introduced into it by Freddie, was printed at the head of a column. But she felt for the first time in the whole affair a cold breath of dissatisfaction.

In the end the victory, though substantial, was only half Freddie's doing, and might even have taken place without her. The Committee, not through any outside pressure, but simply through the natural organic processes of any committee, was suddenly wound down, restructured and reconvened. Although the members were in fact the same as before, with one or two omissions, they felt it was important to work on something different. Partly (but only partly) because of the hints of the powerful, partly to enjoy the luxurious sensation of having enough and to spare induced by the words 'the project has been dropped', they shelved indefinitely the discussion of a National Stage School.

Some time had to pass before there was any hint of the curious effect of the episode upon Freddie. Possibly she didn't know herself, at least at first, what it had done to her. It was at times like this that she

particularly needed a Word to make the future clear. She was glad to be spoken to by something that she could not control.

15

DURING Freddie's silent victory over the National Junior Stage School — and who these days ever refers to that project or even remembers it? — during the actual week, indeed, of the letters to *The Times* — *King John* opened at the Nonesuch. The raddled old theatre, which had seen so many glorious and disastrous nights, and where a Victorian manager had once cut his throat in Box A, unnoticed until the blood dripped down into the orchestra pit, pulled itself together as it had done time and again, to turn its gilded and painted face towards one more audience.

The publicity manager had decided to refer to Ed Voysey as 'dedicated'. What other word would be safe to describe a director who, at the last minute, had changed the lighting plot? Being at a delicate stage of over-rehearsal, where the slightest impulse was enough to drive him off course, and having been most unfortunately shown some Sickert drawings of the Old Bedford Music Hall, Ed was overwhelmed by a quite new way of seeing; he'd give the true Edwardian note, yes, truly Edwardian,

this, by introducing real footlights. None of the cast, of course, had ever worked with them and the younger ones had never even seen any. Urgent signals were sent out without result until Voysey, his wits crazed to unnatural clarity, remembered having seen a set crammed into a storeroom under the stage at the Pier Theatre, Eastbourne. Retrieved and repaired, they had to be connected with the nearest gas supply; this was in a kind of cubbyhole, where the wig mistress sometimes boiled up kettles.

Franks, the chief electrician at the Nonesuch, had his own ideas about the whole improvised apparatus and about the dedication of Voysey. All his own lights would have to be lowered, so as not to kill the gas-light from the front. It was the first time, he pointed out, that he had been asked to take responsibility for a show which would be almost entirely invisible. His relish for disaster was only intensified by the director's enthusiasm. 'But it will be soft, Frankie, soft glowing reflections from the flesh, deep shadows below the chin and the eyebags, as in the old prints and photographs, the old photos, Frankie, the lost magic . . . *with a gesture of total despair he advances down to the footlights* . . . it's going to take them back sixty years as soon as the house lights go down.' On the whole, however, the innovation was a good thing because Ed became obsessed with the problems of raising and dimming the gas and this

prevented him from rehearsing the whole show into the ground.

Meanwhile the small part actors were suffering from nerves, but they had also begun to act the part of actors having nerves, and the delicious falseness drew them together more than the last run-throughs had managed to do. William Beardless also trembled. 'You'll carry me in Act 3, won't you,' he implored Boney. 'I'm not usually like this. God yes I'm always like this.' But after the final rehearsal for light cues he had handed out even more notes than usual to the rest of the cast, and in particular one to Boney himself, not referring in any way to his performance but giving him a number of useful tips on Cutting Down; *today, have your first drink ten minutes later than usual, tomorrow, twenty minutes later, and so on. Every day will be a little easier.* Boney, hoarse and beery at this stage as a down-the-bill comic, had folded the note into a very small paper pellet.

'He just flicked it, Miss Wentworth,' Mattie brightly reported to Freddie. 'I don't know whether he meant to hit me or not.'

'I daresay you're a fairly good judge of that,' Freddie replied. 'Now come on, try it just once again.'

She meant the line *This ship-boy's semblance hath disguised me quite,* which had given Mattie, in common with everyone else who has ever had to speak it, a great deal of trouble.

'Thisshipboyshemblance,' Mattie began confidently. 'Mr Voysey told me to practise it quietly by myself.'

'Ship boy's, dear. Pause after "ship".'

'They gave me a pause after "semblance" yesterday,' said Mattie, with his bright leer.

'Try it again.'

'Thishibboyshemblance . . .'

'Keep it clean, dear.'

'It's not my fault, Miss Wentworth. Shakespeare buggered it up.'

It was too late for anything but Fate's protection, and Freddie kissed him and wished him luck. The Temple children all dreaded this embrace, the odour of Mothaks, unmade beds, sandalwood and old woman that issued cloudily from blouse and cardigan, and with it often the painful scrape of the great brooches — and Freddie knew very well what they felt — but not one of them would have wanted to open in a new show without it.

Freddie's received a generous allocation of *King John* tickets for the right hand side of the stalls. The agencies, gambling on Voysey's dedication, the name of William Beardless, and rumours of kinky sets and costumes, had taken the whole left hand side of the auditorium. Business was not bad at all.

Freddie herself did not go to the first night; she had not been out in the evening since the gala performance

of *Sleeping Beauty* when Covent Garden was reopened after the war. On that occasion, it was remembered, she had looked round at the regal expanse of new Cecil Beaton crimson-striped wallpaper and asked whether there wasn't a roll or two of it left over. Since then she had attended only matinées and previews. Latterly she had hinted that she might consider going out at night again, but the occasion had not been specified or even hinted at.

Hannah, who had been looking forward to the first night so much, did not go to it either. She had most firmly intended that Pierce should come with her, to show that whatever had passed between them must find its own level, and in no way cause any embarrassment from day to day. It was up to her, surely, to manage that, and she had the satisfaction of feeling sensible and wished she had someone to talk to about it if only to reassure her as to how sensible she was. Her mother, who still rang up twice a week, wouldn't do for that at all; with the unwavering perversity of mothers, Mrs Graves remembered Pierce's name out of all the many that had been mentioned to her, asking whether Hannah was having plenty of good times and cultural opportunities and plenty of young men to take her out beyond that Carroll fellow who was teaching with her; and then, for some reason, Hannah found herself defending Pierce, even to the point of tears. — 'Who

did you say his people were?' — her mother had asked sharply.

Hannah owed it to herself to show that this kind of thing couldn't affect her, by going to the first night quite calmly and casually with Pierce. They had to see each other every day of the week, after all, and might have to do so for years. Boney Lewis need not be mentioned between them, and indeed, since that rainy evening outside the theatre, he hadn't been. Hannah had sent him a greetings telegram, like those she had seen in the dressing rooms, and the telegram would be the beginning and end of it. All that remained was to watch his performance which would be a little more interesting, perhaps, because she had actually met him, and then later on to discuss it over a cup of coffee with Pierce. The only drawback was, that if Hannah didn't go with her, the Bluebell might feel neglected. That was a real possibility. A fear that she had in fact been counted upon seized her when Miss Blewett showed her a mauve lace bridge coatee, trimmed with silver picot.

'The tarnishing is scarcely noticeable by artificial light,' she said. 'That's a sign of quality. It was real metal lace.'

'When are you going to wear it?'

'Oh, to *King John*, to the first night.' She turned the garment this way and that. 'I've asked Pierce to escort me.'

Hannah was silent.

'Such a sad look in his eyes, dear, but you mustn't for a moment feel that I'm reproaching you, a young girl can't help her power over men. I've never had a son, of course, but if I had I always thought it would have been so nice to go to the theatre with him and he'd just put his hand under my elbow quite lightly and steer me towards the right gangway.'

Hannah hoped that when the time came Pierce would think of doing this. No one could have the heart to wish anything less for Bluebell. And she herself, of course, was quite free to go with them if she wanted to. She had only to suggest it — perhaps she was intended to — but she didn't. With an honesty which seemed to her less helpful than it used to be, she admitted to herself that she felt put out. The old parish priest at home (not the one they had now) would have called it a bit of a gunk. *We've been walking out now for twelve years, Paddy Casey, and people are saying that we'll soon be getting married. — Are they saying that, Maggie? — They are, Paddy. — Well then Maggie, they've got a terrible gunk coming.* The harmless cruel story from the kindly priest. And Pierce too, drawing quietly into himself in total disappointment, he had had a bit of a gunk. But for that very reason, surely, she was justified in feeling put out. She had meant well, and to be spared carrying out our good intentions is a direct slight from Providence itself. She told herself that she was standing back to allow Miss Blewett to enjoy the outing. But that

too turned out to be an illusion when the pair of them asked Jonathan Kemp whether he wouldn't like to come along with them.

Jonathan was free because he was not at the moment Mattie's understudy but covering for the understudy, a boy of seventeen, very much miscast, and due to be returned as soon as possible to the ranks of executioners, lords, servants and sheriff's attendants. Ed hoped to have Jonathan in the part before Christmas and had told him in passing to try and see the show from the front of the house when he could. What could be better, then, than the arrangements they had made, and what could be more suitable than the mauve coatee, although it was rather too formal for Tito's, where they were all going to have a little something before the show? And Freddie called out from within that if Hannah was going to be on her own that evening, perhaps she would spare the time to come back after work and sit a little with a poor old woman who would be glad of her company.

On a first night the Nonesuch divided itself, like every other theatre, into two parts, as though prepared to side with either. Behind the orchestra pit the illusion prepared itself with the desperation, a noble one after all, of a handful of human beings about to risk their professional future. The front part of the old house, on

the other hand, creaked into cynical relaxation as the first nighters rustled and coughed through the twelve entrances, only half ready to believe that it had been worth while getting there by 7.30. By some law which defied the notion of gravity, the theatre filled from the top downwards. First the gallery, with its terribly steep stairs, then the upper circle, and in the front row of the upper circle the people craned forward, trying to get a glimpse, as the stalls filled up far below them, of the unrecognisable well-known.

Miss Blewett, Jonathan and Carroll attracted some attention. They hadn't either the assurance, or the wish to appear to avoid notice, which would have marked them as celebrities, still it was possible that the queer threesome were somebodies of a kind and that one should have known their names. The little boy, short though he was, had managed to put his hand protectively under the elbow of the white-haired woman in mauve, steering her towards her seat. Behind them, the youngish-oldish man in a blue suit couldn't really be anyone in his own right, but was likely to be her son, consequently the little boy's father. There seemed to be some kind of affinity between them. If you looked carefully, they had the same roundish shape of head.

'What time do we go up?' Boney was enquiring thickly backstage. They were now fifteen minutes behind time.

In these final moments Ed Voysey had discovered that the lights were reflecting too brightly from the crowns in the court scenes and had gone round and with his own hands rubbed over all the jewellery with soap. He appeared completely knackered. His voice, through the dressing-room loudspeakers, was hardly above a whisper. 'I've no more to give you. Go out and throw it to them. Go out and stuff it down their throats.'

The auditorium was still on the move with long gusts of restlessness. But with the opening music the two opposing sides of the theatre gave up their independence and rejoined each other, waiting together, in a momentary truce.

Ed, and indeed the whole company, had relied on a strong immediate reaction to his opening set. Elgar faded to the music of a brass band thumping from a distant lawn, and Shakespeare's court appeared as a lavish billiard room at Sandringham, where King John, perhaps rather implausibly, was receiving the envoys of France. The great chandeliers were lowered, and royal footmen, narrowly missing each other as in a ritual dance, circulated with trays of brandy and soda.

Ed was listening for the immediate and irrepressible gasp and murmur from the house which is like the darkness talking to itself. He caught, alas, only the faintest snatch of it. Most of the audience, faced with an

unfamiliar play, were bent over their programmes. They could have read them more easily earlier on, but chose to do so now. They accepted the presence on the stage of the Lords Salisbury and Pembroke, because the play was by Shakespeare and that was what Shakespeare was like. But they did not expect to be asked to distinguish between one lord and another, unless there was a war or a quarrel, and it was this that was causing them anxiety. *Pembroke, look to it; farewell, Chatillon!* cried King John. William Beardless paced this admirably, pausing in the middle of the line and selecting a cigar from a silver box offered by a footman. The heads of the audience turned to one another: Good, that must be Pembroke, then, and the one going out must be Chatillon.

The deputy stage manager leaned against the prop table, his head bowed low. 'The Sandringham set, the footlights ... they aren't giving a fuck ... they simply aren't looking at them ... it simply isn't good enough, not good enough for them to look at ...' In going on like this he was giving an imitation, as far as he knew how to, of Ed. Those who create illusion must live by illusion. But Ed himself, now that his play had actually begun, was transformed. Pale, determined, without misgivings or reproach he prepared to go up to the private bar, at the end of the short first act, to meet the Press.

The Press (in the sixties the notices appeared in the newspapers the following day) were agreed that the play

came completely to life only in Act 4, with the prison scene. During this scene something totally unexpected had taken place. It had nothing to do with little Prince Arthur, who looked altogether too cheerful and confident. But at the point where Hubert shows the child the royal warrant authorising his torture —

> Read here, young Arthur.
> I must be brief, lest resolution drop
> Out at mine eyes in tender womanish tears.
> Can you not read it? Is it not fair writ? . . .

— at this point, then, Boney Lewis, that easy-going, unambitious, acceptable character player, achieved the moment of electrifying contact with the audience in front of him which may only once or twice in a lifetime be the actor's reward. Out of seventeen hundred spectators, not one stirred. The quality of the attention, even the texture of the silence, changed. The theatre had bound its spell upon them.

The fact of the matter was that when Boney snatched up and unrolled the warrant, with its dangling seal, the words that confronted him were: *Just a little hint on Cutting Down. Today, have your first drink ten minutes later; tomorrow, twenty minutes later, and so on. Every day will be a little easier.* The critics, with justice, praised the struggle for self-control which he so strongly and yet delicately expressed. 'As Lewis

first produces and later tears up the crucial document which orders the blinding of an innocent child totally at his mercy, the dialogue between unthinking political obedience and human decency springs to dramatic life. What Hubert decides at that moment, the Third World may have to decide tomorrow.'

Mattie, who had intended to steal every scene in which he appeared, and felt, indeed, that this was his right, was considerably thrown out by Boney's success. He hadn't expected this outcome of his joke with the document; chipper though he was, he was too young to know how to recover himself in time for his next appearance, *Enter Arthur on the walls*. The Jump, which he had fancied less and less as rehearsals went on, was a tame affair. Safe on his mattress, Prince Arthur expired with evident relief. To cover this, Ed Voysey sent the ever-useful Lords Pembroke and Salisbury on stage to find the body somewhat earlier than their cue.

'A little disappointing,' murmured Miss Blewett. 'Mind you, that's not our Mattie's fault. It's entirely the director's responsibility, to make it tell. What did you think of it, Jonathan dear?'

'It was terrific,' Jonathan replied, unwilling to betray his friend to adults. 'Mattie was fabulous.'

But in any case it would have been hard for him to explain what he felt about the play, since although he had sat through it with rigid small-boy's attention he

had barely registered the Prince Arthur passages on stage, because clearly superimposed on them in his mind, word by word and keeping pace with the performance itself, were the scenes as he knew they ought to be. Far from imagining himself as a centre of attention or as taking part in any way, he sat in passive detachment as this second play took its course, only coinciding with the real one when Mr Lewis tore up the king's warrant. At *Must you with hot irons burn out both mine eyes?* he saw Mattie spreading his arms wide, rather as if he was just about to sing, but he also observed a different Prince Arthur, pressing his hands into his eyes to find out what it felt like to be blind.

'What kind of ice-cream would you like, Jonathan?' Carroll asked.

'They only have Dairy Dips at the Nonesuch,' Jonathan replied. Miss Blewett confirmed this. Carroll felt disappointed. Conscious of his shortcomings as a playgoer, he had hoped to make up for them by being a generous host.

'But do you like Dairy Dips?'

'They're fabulous.'

But as soon as politeness allowed Jonathan disappeared backstage. Once there, a creature in his natural habitat, he made his way lightly and quickly to the dressing-room which Mattie shared (when there was absolutely no help for it) with seven others. Mattie, who had insisted that

Jonathan should come, was lolling, but not relaxed, in his pretty pink and white make-up.

'We're going to take three calls at least. I can't make up my mind whether to take my call in character or not. If I'm still in character I'll have to go on looking pathetic, I won't be able to smile at them, will I . . .'

'What did they tell you to do?'

But Mattie's worry lay deeper. 'William said I was very good . . . how was I, anyway?'

But as though to prevent any possible answer, he jumped up. He would rather have had praise from Jonathan than anyone else on earth, but now felt the necessity to tease and harass him and depreciate him to the half-listening members of the cast who hurried in and out, and finally to hold him down and pretend to put out his eyes with a half-used stick of Boots greasepaint.

In the meantime Miss Blewett was telling Carroll that they mustn't waste the interval but must stretch their legs a little and go for a stroll to see who was there. Did she know anyone who was likely to be there, Carroll asked her, but it seemed that was not the point and that she was a little like his sisters who went to the shops not to buy anything in particular but simply to have a look at the things and turn them over. In the ludicrously crowded bar it appeared that life itself, for the spectators, depended on passing a number of drinks over the heads

of the forward ranks to those in a dangerous state of thirst in the rear. Carroll, mildly persistent, was successful here against all expectations, returning quite soon with a glass of Wee Robin for Miss Blewett. — I don't know much about this drink, I hope it's what you wanted — he said — I believe port is one of the constituents.

'Don't tell me!' Miss Blewett cried. 'So often it's best to leave things a mystery.'

Fortunately it turned out not to be true that she knew no one there. From her years with Freddie and the variety of ways in which she had earned her living since the age of fourteen she had made so many acquaintances that it was a safe bet, almost anywhere, for her to wave and sparkle, as she did now, and to raise her Wee Robin to shoulder height, saluting humanity in general. Carroll, of course, had no opportunity to follow her example. He felt out of place, and would have been glad to hear Old Ernie barking. But for him, all time spent away from Hannah was a kind of limbo, into which the hours dropped without distinction.

Hannah had told Freddie that she wouldn't be able to come back after work and sit with her. Freddie in return assured her that there had been a little misunderstanding. 'It was simply that I was afraid that you mightn't want to be on your own, dear.'

Hannah experienced a strong impulse to sit on the

floor or some low piece of furniture and to confide in Freddie and acknowledge her power, and trust her absolutely. These impulses only come over women at certain times in the day and tea-time is one of them. But she knew that if she gave into it she would value herself less, and so, too, would Freddie.

She went back by herself to her room, put all the drawers in order, dusted, did the ironing, sewed back the loop in the neck of her dressing gown, oiled the hinges of the still unsatisfactory door, made a list of the letters she ought to write, threw away a number of things and then decided after all to keep one or two of them because they were perfectly good, and then washed her hair, holding her head cautiously under the taps of the little sink, and afterwards brushing it dry in front of the modest electric fire. She watched all the length of her hair roll away from the brush in a warm shining cloud which she confined in a rubber band to give it a curl. The nuns were most insistent that if you washed your hair too often it went grey much earlier; her mother, for instance, had gone grey at thirty. And, as they often did, the mysterious certainties with which one generation keeps the next in check came back to her, soothing now, because they had lost their power. If you hit your glass with a fork a sailor gets drowned somewhere. If you drop the fork it loses an ounce of silver. Don't make faces like that or the milk will turn. Don't carry on like that, you're only play-acting.

She was in bed and nearly asleep or perhaps had been asleep when Boney arrived. He invaded the tidied room from the unpeaceful outside world, impelled by the recoil of spent emotions and lavished drink and deep fatigue. She hadn't remembered to lock the door while she was fixing it and here he was, staggering and demanding, a huge alien.

'You never came round!'

'I wasn't at the theatre at all tonight,' Hannah said.

That was beyond him. 'We opened tonight!'

'I didn't go!'

'I held them for three minutes, you know. You can't be great in the theatre for more than three minutes. But you didn't come round afterwards. Hannah, you didn't come.'

If the Bluebell had not needed her, Boney evidently had.

'Boney, have you been drinking?'

'Yes, thank God.'

Hannah switched on her bedside light. He stood there blinking his blue eyes, which he always kept half closed, as though to save trouble if he felt like going to sleep.

'Did you get my good luck telegram?' she asked.

Clinging on to the bookshelves, which admirably met the strain, he sank into a chair. Now he had an air of permanence. Something would have to be done about him.

It was of no use going on about the telegram. Probably he hadn't even got it. No one who sends a telegram is really surprised when it doesn't arrive. 'Where are you supposed to be, Boney? Have you got locked out? Why did you come here for heaven's sake?'

'Your place is so tidy,' Boney mumbled. 'It's not every girl who tidies up before I come.'

'How did you know where I live?'

Seeing and hearing that he had fallen asleep she got out of bed and put on her raincoat. It was very cold in the room and although it was only November there had been something on the radio about snow. For a guest, of course, she would have put on the fire at once, but Boney was hardly a guest; he looked so comfortable, however, that she began to feel more like a visitor herself. His antiquated gold watch ticked away peaceably on his wrist.

She ought to find out what his address was because somebody might be missing him and worrying. That meant going through his pockets, which wasn't the kind of thing Hannah did or had ever seen anyone do, except in a film. Her mother (and 8.15 tomorrow morning, or by now it would be this morning, was the time for her telephone call) would consider it low. But, even if it was low, it was certainly quick, because Boney seemed to have nothing in his pockets at all, certainly no money. Perhaps he had come here because he hadn't

been able to pay the rent. Hannah still thought of actors as airily unconcerned with practical details. What would he have done if the door had been locked?

It was disconcerting to find a leather folder exactly where you'd expect it, in his inside breast pocket. There were no photographs, only a cheque-book and an Equity card, no pen, no address-book, but this was certainly the place for addresses. Leaning against his knees she discovered, turning over various bills and postcards, that Boney had a house in Hampstead – no 4, Well Lane – and, as Sr G. Sebastiano Lewis, apparently a place in Venice as well. So he couldn't be hard put to it for money, or indeed for somewhere to go to. There were keys, too, in the pocket of the grand overcoat, now heaped on her floor. She felt glad for his sake, although of course these addresses might be fantasies, he might have felt impelled to make them both up. It did not occur to Hannah that as a good unambitious character actor, never out of work, Boney was earning very well.

With the postcards was a folded title page torn out of a Junior Geography, with her address on it in Mattie's handwriting. He had added: *Mr Lewis. This is it, no mucking about, I got it off our other teacher.*

She got back into bed and lay there, cold as the frost outside. The clock from the Prudential Building struck two, and at the plangent sound Boney seemed to revive, as though these were his appointed hours.

'Where are you, Hannah? What have you been doing?'

'Looking through your pockets and trying to find out about your affairs.'

'Wonderful, that's what I came for.' He began to undress, adding, 'I'm only doing this for you, it's terribly cold.'

'Is it snowing?'

'Now you've stolen my line.'

He climbed into bed and the whole little 2ft 6 mattress sank in protesting acceptance. Hannah felt happy, and indeed that was the effect Boney knew how to produce. In spite of his impersonations of outrage and dismay he was completely at home with the world, having made a kind of arrangement with life not to undertake anything he couldn't comfortably manage, while enjoying the pretence, from time to time, of needing to be managed himself; this was one of those times. His close presence was like that of the genial inhabitant of a den.

Boney pointed out that her hair was damp and had just been washed so that evidently she must have been expecting him. He appeared to have sobered up completely, and carefully took off the rubber band, spreading her hair over the pillow. 'I'll tell you another thing, my dear,' he said. 'There's a system that's been recommended to me, a hint I've been given by a very distinguished member of the profession about cutting down all this

kind of self-indulgence. Tomorrow I'm going to start ten minutes later, the night after that twenty minutes later ... and then I'm going to see how much good it's done me.'

16

SHE had another key to her room cut by the Cypriot who had mended her shoes when she first came to London, and who did that kind of thing as a sideline; he looked at her mournfully as he handed back the two keys, implying that London corrupted. She never knew whether Boney would come or not, or where he was when he didn't. It would have been quite possible to go up to Hampstead and find out whether he really had a house at 4, Well Lane, but the thought frightened her. It might destroy the little that she had.

Well, once she had been great with John Brannon, and now she supposed she was great with Boney Lewis; it puzzled her all the same. The Bluebell had warned her, during her very first week at the job, that not only did theatre people talk about themselves all the time — that was nothing, after all — but they found it impossible to take any real interest in anyone outside the theatre. Hannah knew that this was true. It was true of even the smallest of the Temple children. Gianni, of whom she often thought, removed by the dissatisfied tailor back

to the daylight world, must have found it painful to adapt. Trying to make this clearer to herself she had once asked Pierce — but this must have been quite a while ago — whether he didn't find it rather sad to see human beings giving a lifetime's concentration to what must melt into air, into thin air.

'I think that's a bit from Shakespeare you've got there,' Pierce had said.

'Well, yes.'

'If you ask me, he was a bit of a showman.'

After the spare key was ready Hannah ordered an extra pint of milk every other day and bought some extra cans of beer and abandoned herself to the passing moment. She went to see *King John* by herself, three nights running. Boney was still making a remarkable success in the prison scene, all the more so because the audience knew about it and were ready for it. Even though the original effect had been produced entirely naturally by surprise and fury, a certain corner of his mind had registered professionally exactly what he was doing, and he was able to produce it, though in a broader and coarser form, night after night after night.

She knew that he wanted to amuse himself, and see if he could make a schoolteacher laugh. He did make her laugh. Heaven knows she ought to have been used to impersonations by this time, certainly she knew they were the lowest branch of the art, but they beguiled her

just the same. When he had gone the room seemed full of the other voices he had brought into it, and even the kettle, whose wavering whistle he imitated exactly, spoke like him. He told her that as soon as the run of *King John* was over he wanted to take her to Venice.

'Have you got a place there?' she asked.

Not quite as grand as a place, he thought, just two or three rooms in someone's house off the Zattere. Two rooms or three rooms? she asked, but saw that he had genuinely forgotten.

'I shall have to see,' she told him firmly. 'I don't suppose I should be able to afford the fare.'

Boney looked at her indulgently. 'Don't worry, perhaps I shan't be able to either by that time.'

That struck her as a fair warning. There must be a system for preserving one's independence, it was only a question of working it out. In the first place, whatever happened, she must stop regulating her movements by his. For this reason she did not go to the Nonesuch for the next two evenings, and in that way she missed seeing Mattie's accident.

After his uncertain opening Mattie's performance had been lacklustre, and in spite of extra rehearsals called by Ed, it had remained so. He seemed not to be able to tighten up, except, unfortunately, in the carry, where limpness was required. Mattie came to Freddie's office,

and sobbed, 'I can't get on with Mr Lewis. I've done everything I could to get into his good books, but he doesn't like me.' Freddie consoled him, but told him that she couldn't — by which she meant that she wouldn't — interfere. William Beardless drew Ed aside, and begged him to put the whole thing to rest.

'He's tacky, William.'

'But I happen to know that the child's worried to death at the thought of having failed you. He can't bear to cause anyone disappointment. Give him time, Ed, give him space.'

In the following night's Act 4, Mattie appeared on the walls, lingered in the spotlight, took off his straw hat, put his hand to his forehead, swayed noticeably, walked down several steps lower, crumpled, rather than leaped, on to his mattress and then sat up, rubbing his left shoulder imploringly. A shuffle of concern ran through the spectators from the front of the stalls to the back, and from the top of the gallery downwards.

'Oh, please, there's something broken . . .'

At such a moment the old theatre might regret the days when there was a curtain to be lowered. Not only the loyal lords but the St John's Ambulance personnel hurried on to the stage, and with them, clean counter to the sense of the play, King John himself. Unfortunately Beardless could not speak other than clearly and his exclamation, 'Speak to me, you little scrubber! Tell me

you're not dead!' carried to the back of the house. Mattie, whatever shortcomings there had been so far, did not fail his great moment. Lying like a broken plaything, then raising himself with difficulty on to one arm, he favoured Beardless with a languishing glance.

In a television interview which he gave nearly twenty years later, Mattie Stewart recalled, or at any rate insisted, that he had damaged himself deliberately that night at the Nonesuch for one reason only — because he recognised the talent of another young actor and wanted to give him his chance in the part as soon as possible. He was speaking, of course, as Stuart Matthew, a celebrity in every country where conditions were sufficiently settled for movies to be shown, and if he could look back on his Prince Arthur of 1963 and remember his collapse as a matter of pure self-sacrifice, then that must be the truth for the theatrical historian. Perhaps it was. Love and jealousy feed on the future even more readily than the past. Mattie might well have wanted to hurry on the keenly-felt moment when Jonathan would play Prince Arthur better than he could. On the other hand the accident certainly earned him, for the first time since his letter to *The Times*, a mention in the Press.

Ed was able to announce from the stage, before the beginning of Act 5, that there were no bones broken, but after a further examination Mattie was said to be

shocked, exhausted, and emotionally drained. Beardless offered to go out of the play for a few weeks to take him to recuperate somewhere in the sun. Freddie, being made aware of this, wired to Mr Stewart and advised him to come back from Zurich immediately.

The understudy could only be tolerated for two nights, Jonathan was to go in on the Friday. That gave him, from the time when Mattie was carried into the wings to his own first appearance, about seventy hours to get perfect. But he had been rehearsed already, and after all, he had been supplied by Freddie's.

Although Jonathan's serene manner remained unaltered, his entire horizon was now filled with the interpretation of his part, that is to say, with the problem of becoming princely. His vision or double vision of the torture scene during the first night at the Nonesuch had apparently been a case of 'seeing true'. At least, at the run-through on the morning after the accident he had covered his eyes with his hands to give the idea of imagining blindness and Ed Voysey had shrieked from the stalls: 'You're doing something rather good there, keep it, keep that rather good thing in.' The assistant stage manager had noted it down accordingly. But the matter of the Jump remained in doubt, since Ed's only direction had been to do it any way he liked as long as it was full front and he didn't screw himself up. A new and specially low projection had

been built on to the wall not more than three feet above the ground and the instructor, in whose hands the whole thing had been left, was going to make Jonathan take off from that.

But Jonathan knew that Arthur had jumped from the top. What kind of a boy was he, well, obviously quite a good actor himself, something like Mattie, able to get round Hubert and soften him up and rapidly reduce him to tears. Jonathan saw that Arthur was not naturally courageous. As a prince, however, he had to make himself behave in a princely manner, however senseless that might turn out to be. The best way to escape would be to have another go at Hubert and steam the keys out of him. The princely way would be to jump from the wall, but only from the very top.

If he could bring it off successfully the first time, without causing anyone any trouble, Jonathan was prepared to bet that it would be written into the book and accepted for the rest of the run. His concept of the future ended there. Then there was his hat. That had got to sail slowly down behind him.

Practice was needed on the spot, and for practice he needed reassurance, or, failing that, at least attention. For the last few years he had never really been short of either, so he could hardly be blamed for expecting them now. Jonathan had never been particularly worried at having an agency in place of parents, any more than the Darling

family in *Peter Pan* were worried by having a dog for a nursemaid. He considered himself, and was considered, as a child of the Temple, Freddie's child.

Behind the school there was a little walled yard, oddly shaped, almost three-cornered, either because the ground had been appropriated at some earlier stage from the house directly behind, or because the street had encroached a little on the back of the Temple. The street lamp, in fact, was right up against the wall and a groove had been cut into the bricks to accommodate it, so that it cast a light into all but the near corner, which was profoundly shadowed. Freddie had frequently been pressed to rent out the yard – as her lease permitted her to do – by garage proprietors, pigeon fanciers, market traders and even by the Theatre Royal, whose scenery docks were hopelessly overcrowded. But the notion of possessing a coveted empty space in the thronged city's heart appealed to Freddie. Her acquisitiveness gave way, in this instance, to a deeper sense of what was due to her.

The yard, however, had in a certain sense become, since he was six years old, the property of Jonathan, although his rights were fiercely contested by a last claimant, Baines, the odd-job man. Baines, like Freddie, had no real use for the few square feet of space, and was acting merely out of the territorial instinct. He had only been able to talk of having nowhere to stow his bits and pieces. Jonathan had remained in possession because it was

there that he conducted whatever he had of home life. Having been allowed at one point to keep a guinea-pig, he had fixed up some kind of a hutch, while Mattie, trying for detachment, had hovered about, offering advice and prophesying disaster. The guinea-pig had quite soon been killed and eaten by one of the half-wild cats which patrolled the theatre district. Only the soles of the feet were left unconsumed, so that although the empty hut remained, a grave had to be dug by its side. The yard was paved with bricks, so it was only necessary to remove half a dozen and replace them. The bricks had stayed loose ever since in case Jonathan wanted to conduct an exhumation.

In his present emergency he had measured the walls during the lunch break and calculated that they were between seven and a half and seven and three-quarter foot, just about right for the purpose. As the day went on it seemed to him that the trajectory and landing were on the whole less important than the take-off, because that might be slippery. The rain which had been falling lightly had turned to sleet, half way to snow, and as soon as it was dusk the flakes could be seen spinning against the shaft of light from the street lamp. The top of the wall grew white, but that could be cleared off easily.

A wise child, Jonathan had every intention of taking direction, but in devising this rehearsal he was, after all, only doing what Mr Voysey hadn't time for. Everyone

had to run through the bits that weren't quite right in their spare time; Miss Wentworth had been on at Mattie all the time about the ship-boy's semblance; really, there wasn't such a thing as spare time. It took fifteen years to make an actor, by which time Jonathan would be decrepit, over twenty-four. Your character was formed by that time, you'd finished growing, and it was difficult if not impossible for you to learn anything new. What mattered was to concentrate your energy right at the beginning, for example when you were studying your first part. That was how things were done.

Jonathan's ideas of how to do things were, as indeed they had to be, those of a nine-year-old — one who had entered an adult profession, but still a nine-year-old. By listening to, but far more by watching, the world that confronted him he had mastered a number of given rules which seemed to him to cover the whole conduct of life. But he was not old enough, or anything like it, to realise that the rules might be evaded, time and again, by the givers. Deeply pondering, and with ears turned purple by the cold, he went in through the back door to ask for help in his emergency.

Hannah and Miss Blewett, understanding the ways of almost benevolent tyranny, had told Jonathan that he ought to confide more often in Freddie. But if he hadn't done so, it was very likely a further proof of the parental shape she occupied in his mind. She was essential to him,

but always accessible. He had never been asked to feel afraid of her, or afraid of her not being there. There would always be another time for him to go and see her. It was only this evening that he needed her at once.

The difficulties of the project — of getting her out of her office, or even out of her chair, and into the back yard, where he had never even seen her, on a dark cold evening — these hardly occurred to him. It was forty-six hours to his first professional appearance. He was confident that if she was reminded of this she would never reason the need.

'I'm afraid she won't have time to think about it tonight,' Miss Blewett said. 'She's going out.'

'She can't be,' Jonathan replied. 'She never goes out at night.'

'She's going out to dinner tonight, dear. I'm on my way now to look through her wardrobe and see if I can find her something dressy to wear.' And both were silenced for a moment at the enormity of the task. Even Jonathan was side-tracked by genuine interest and amazement.

'But she hasn't even been to see *King John*.'

'I know, dear.'

'She hasn't got anything dressy.'

'You don't know everything she's got, dear.'

'Where's she going? Is she going out by herself?'

The Bluebell was glad to have anyone to share her

amazement. It had only been a short while ago, when she was checking on the supplies of Ovaltine, that Freddie had announced that she was dining at the Ristorante Impruneta with Joey Blatt.

'I must admit I was rather taken aback. Over the years there have been so many, many invitations declined, and I should have thought if there was going to be an exception it wouldn't have been ... I mean, she even declined the Master's little supper party ... of course she hasn't forgotten your first night, dear, but that's Friday, and this is only Wednesday. You must come to the office first thing tomorrow, whatever it is, and tell her about it.'

'Does she like Mr Blatt?'

The Bluebell patted her curls. 'He's a business man, dear.'

But by now Jonathan's self-protective politeness had returned. 'Well, I don't think I'll worry her about it tomorrow morning, thanks all the same, Miss Blewett. It's just something that I have to do this evening, some-thing out in the yard, really.'

'But it'll be quite wet there, dear, I expect. What are you doing with that straw hat? You'll put on your wind-cheater, won't you?'

Their diverging obsessions gripped them, and they parted.

Jonathan went outside to consider various methods of

reaching the top of the wall. The snow still fell but was not troublesome to him. There were no toeholds in the brick, but the hutch stood in the dark corner of the yard and would give him a good step up. However, he didn't want to start there because from the top of that wall he could be seen from the street. Someone passing by might interfere, and, worse still, to be seen by a stranger would be unlucky. If anyone saw your performance before your opening night, that was unlucky.

The hutch must be moved, but it was very heavy; this was because its base was a small mahogany sofa-table from the salon, turned upside down. Now, warped by the London winters, it clung solidly to the dank ground. No shove, no pushing and pulling, on Jonathan's part would unwedge it. However, Mr Carroll was probably still somewhere about the place. Nowadays he was often there quite late. Some people said he was economising and didn't want to go home and put shillings in the meter. But Jonathan knew that Carroll was above that kind of thing.

Miss Blewett, hurrying past, but still unable to keep her news to herself, told the doorman that Miss Wentworth would probably require a taxi later. In superstitious terror, Baines damped down his boiler and left the building, not feeling himself until he saw the slanting square of light which the Nag's Head windows threw across the

pavement. To do him justice it was not the unknown he fled from, but the unexpected. 'Why? Why?' Miss Blewett murmured, and Freddie, majestically waiting in the bedroom for her assistance, replied: 'We change completely, you know, every twenty-one years.'

Into this bedroom Miss Blewett had very occasionally been, in times of illness — on the afternoon, for example, of Freddie's collapse to pack her case for the hospital — but she had never looked into the wardrobe. She knew the bed, yes, a narrow mattress such as nuns and prisoners die on, covered with a red hospital blanket and over that a fine cashmere shawl which was not quite large enough, so that a space had to be filled by a rug of sacred monkey fur. Beside it a chair waited piled with cushions, since Freddie, who made it known that she had not slept for more than an hour at a time since 1935, often passed the night half sitting up, as though holding an audition for those no longer present. A lamp with a long fringed green silk shade, a Bible, a dictionary, a tin kettle with a long spout, of the kind that used to be kept ready in cases of pneumonia. There was in the room no comfort, no welcome to the tired, only the absence of freshness and the indisputable suggestion of Freddie's presence. The room seemed colder than it could possibly be outside.

Freddie had a dressing-table, with a mirror secured by two wooden knobs which did not function as perhaps once they had, so that the glass swung backwards and

reflected anyone who looked into it only below the waist. On the dressing-table a small white china hand spread out its fingers to receive its owner's rings for the night, but Freddie never took hers off.

As Miss Blewett struggled hesitantly with the wardrobe her employer shoved in impatiently behind her and executed a subtle turn of the key which made both doors creak loudly and fly wide open. Hardly knowing what she expected, Miss Blewett peered into darkness. Very little was hanging there, but what there was looked stately. She detected a glimmer, and the rank odour of neglected fur.

'Is that gold?' she asked.

'Peer's robes,' Freddie answered carelessly. 'Mount-pleasant gave them to me, in case we ever wanted to put on *Henry VIII.*'

'When was that? Didn't he want them himself?'

'He was the last person to call me Girlie. There's no one left to do that now.'

'You're not thinking of wearing them tonight?'

The dresses, also, had been presented by various well-wishers. Miss Blewett lifted one from its hanger; it was entirely crocheted from black silk with a deep border of what she recognised at once as real beetles' wings. The great Maria Casarès, it appeared, had worn it as Lady Macbeth, when she appeared before an audience of three thousand in the sleepwalking scene.

'But it's black,' Miss Blewett cried, outraged. 'You can't sleepwalk in black.'

'You're right there, dear, for once. Sleepwalking is much more innocent than sleeping. It's a proof of conscience. But I shall need to keep awake this evening.'

To wear the black crochet would be the assumption of the superb. Whatever size it was it would, or should, stretch. But what ought to go on underneath it? While Miss Blewett's mind circled round this problem, unwilling to approach it too directly, she found it solved. Freddie raised her arms, impressive in volume beneath her dun cardigan, confidently waiting.

Miss Blewett understood, but hesitated.

'Your jewellery, Freddie dear. That should come off, surely.'

This evening it was a heavy cameo from which depended, at the end of a short gold chain, a jet medallion carved with a view of Whitby. Lower down, more jet brooches were scattered.

'My beads may stay,' Freddie declared in a hollow tone. 'You may draw them outside the neckline when the dress is on.'

Miss Blewett, who had worked more than once as a dresser, made no comment, but lifted the musty shining garment up to its full length and lowered it like a tent over her employer's head and on to her shoulders. Freddie's face emerged and was seen in all its absolutely

uncompromising plainness, while her spectacles flashed above the dark pavilion. The brooches were repinned.

'It's a pity you've never managed to pick up any jewellery, dear,' said Freddie complacently.

'We're still short of a coat,' said the Bluebell. 'It's snowing outside, you know.'

She was expecting to be asked for the loan of her coney full-length, and was mildly looking forward to refusing it, as she had an engagement (for which she was already late) herself. But Freddie now recalled that in 1952 she had been made an honorary doctor of the University of Leeds, and demanded, from the very depths of the wardrobe, her furred gown and mortar-board.

Miss Blewett emerged half-smothered.

'These will scarcely be warm enough. If we can't get a taxi to come we may have to walk a bit before we find one.'

'Call no cab, dear. Blatt, of course, is fetching me.'

'But why Mr Blatt? Why? Why?' Miss Blewett wailed.

17

JONATHAN was right in thinking that Carroll was still in the building, but was surprised to be asked what he was doing there himself, and why he hadn't gone home yet. He felt that Carroll would know this without being told. Enchanted by his own difficulties, he had overlooked the fact that, so far, nobody had been told.

'Sir! I want you to come out into the yard.'

He spoke as a prince should speak, and 'Sir' was right for the occasion. Really this was his best bet after all, because they had already discussed the Jump quite seriously between them, and Carroll was presumably strong enough to move the hutch. Suppose, however, that he wasn't? It struck Jonathan now, as he turned his clear bright unembarrassed chorister's gaze on the schoolteacher, that Mr Carroll had gone off terribly. You couldn't say it was gradual, it had stepped up over the last few weeks. There was more leanness, more bentness, one or two less shirt buttons, less ability to get it together in any way, less shape, less hope.

When he had first come into the classroom Carroll,

who was standing at the window looking down into the street, but not doing anything of any perceptible use, seemed almost glad to be interrupted, and certainly ready to listen. But as Jonathan repeated his request, varying it a little — please, Sir, I want you to come down to the yard straight away — he started violently away from the window as though he'd been hit with an air-gun pellet.

'I'm very sorry, I can't do anything for you now. I'm going out.'

'Have you got to go out at once, then?'

'Yes, I may be too late already.'

He snatched down his raincoat which was huddled on the back of the classroom door.

'Is it Miss Graves?' Jonathan asked, with no pretence of belief.

'It is.'

'She isn't here, she left ages ago. Where are you meeting her?'

'Outside.'

'Will she know she's supposed to be meeting you?'

'She will know.'

Jonathan followed his teacher out of the room and saw him making a fool's progress down to the hall while his raincoat, only half on, flapped and swept each stair in turn. Carroll had gone off work, but Jonathan was left with his.

The slamming of the front door reminded him that

he would have to be careful about the back. When Miss Wentworth left for her dinner party she would presumably lock up at the back or see that it was locked, so that he would have to hurry. No hope now of moving the hutch, so the best thing would be to borrow a couple of fruit crates from the market, dragging them back one by one. There were piles of the ones he needed, the large size, all along Floral Street. If challenged on the subject, he could say they were needed at Freddie's. His faith in those words, as a charm or spell, was absolute.

Carroll had seen Hannah on the other side of the street. Out of all the girls wrapped up against the weather, out of all the young women in existence, it only took him a second to recognise her, he had made so deep a study. He issued from the Temple School with all the force of his purpose, and caught up with her by Covent Garden Underground Station. Sometimes she travelled the one stop back to her room by tube.

The rush hour was not quite over and the two of them standing there on the pavement were a great inconvenience to everyone else. Treated as an obstacle, they were spun round now and again almost in a quarter circle away from each other and back again by those hurrying past, avid for the foetid homegoing warmth of the Underground. Sorry ... sorry ... sorry ... sorry.

'I'm not sure that I can discuss anything with you here, Pierce.'

'I daresay you don't want to discuss anything with me anywhere,' said Carroll, taking her elbow in his gentle grip.

'Why does it have to be now, Pierce dear? Couldn't you have told me about it today at the school, I mean if it's anything important?'

'I saw you from the window. I didn't know till then how important it was.'

'You must have been staying late again then. Hadn't all the children gone?'

'All of them only Jonathan.'

'You ought to have sent him home.'

'The school is his home, you know that.'

'Did he want anything?'

'Don't put me off, Hannah. Standing there I had a fancy that you might pass but I knew it was very unlikely as good as impossible and when I saw you I knew I ought to speak at once, just to make something clear. I thought of it, really, as a last chance.'

Hannah suggested — because she knew they always closed at seven — a Lyons teashop. She had taken so readily to Boney's heartwarming shifts and evasions that by this time she couldn't face more than half an hour of sincerity. But then, she told herself, how could she tell what was coming next? Perhaps all Pierce wanted was

to know what she'd like for Christmas. Far from being reproachful or demanding, he had never referred in any way to his suggestion of marriage since the day he made it. At first she had thought that he had taken it very hard but had concealed it and would be pleased if he thought she had been taken in by the concealment. Then she had begun to find it possible to believe that the whole notion had been a kind of freak and hadn't in the end meant so very much to him; after all he'd put all those bits of paper of his away again with scarcely a word, and since then he'd gone off quite calmly, for instance, to the Nonesuch with Miss Blewett. He had never said a thing about the night they'd had together or as to whether he felt more or less of a real person; he had never so much as called round at her place again, and she thought the more of him for that, or perhaps, to be honest, she thought less. As to the sad look the Bluebell had been on about, what did it amount to, he looked much the same, not thinner or neglected. At this point it came to her that she was not good enough for Pierce, and nobody can bear this feeling for any length of time.

Lyons teashops might almost have been particularly designed for the resolution of such awkward situations, and perhaps when, fifteen years later, the teashops were discontinued as uneconomic the situations disappeared with them. In a Lyons, as Hannah had reflected, the limits of communication had to be reached by seven

o'clock, while at the same time it was necessary to share a table or at all events to sit very close to other customers, so that although everyone restricted their elbows, their bodies and their newspapers and by a long established convention showed no signs of understanding what they overheard, they provided all the same a certain check on human intimacy. The rosy-tinted looking-glasses on every wall also acted as a restraint on the undemanding clientèle who would rather keep their eyes on their plates than be caught looking at their own reflexions.

At Lyons, the females, if escorted, sat at a table and 'kept the place' while the males queued for what was needed and carried it back, as their remote forebears had done, with difficulty. During this process the tea overflowed into the saucers. Later the sugar, which was only put out on every fourth table, had to be borrowed and exchanged. There was always a good deal of apologising at Lyons.

The surface of the tables was covered with a material imitating green marble, and on this Carroll, having fetched their tea, planted his elbows, careless for once of the wear on his jacket.

'It was good of you to come, Hannah.'

She felt a longing, more for his sake than her own, to cut the whole thing short.

'Oh, Pierce, I thought you were getting over it.'

Carroll considered this.

'It's a way of describing it, but it doesn't appeal to me because it suggests that what I feel for you will be left behind at an ever increasing distance. That I am quite sure won't happen.'

'But it must happen in time.'

'No, that won't be the way of it,' he replied with that terrible quiet decisiveness which should have been able to move mountains.

'You don't want to keep thinking about me, Pierce. It's a waste of time.'

'Time is not money, Hannah. You talk too freely about wasting it.'

'It's gone in either case,' she cried.

'Not at all. It isn't gone. I could tell you everything you said to me and how you looked, and, I think, what you wore on any given day since I had the good fortune to meet you at the beginning of the autumn term.'

By common consent, and without looking round them, they both lowered their voices which had been raised above the teashop pitch.

'Hannah, I've tried to see to it that I only think about myself a certain fixed amount every day, and that would include talking about myself. But, all the same. I'd be interested to know why you think that I shouldn't feel very much.'

'Don't misunderstand me, I don't mean that there's

anything lacking in you, quite the contrary, I'd give the world to be the same.'

'The same as what, my dear,' he asked.

'Well, I admire the way you always keep the same face, and won't let yourself be put out when the classes play up, and the way you talk to Jonathan Kemp just as if he was no different from yourself, and as to anything else, I'm talking now about personal relationships, there I think you're quite right too, by far the best thing is to accept what comes and not to go on about it.'

Carroll sighed. 'I expect you're referring to the 17th of November, the morning on which I asked you to be my wife. If I had my time over again I think that I should put it in a different way. The upshot would be the same no doubt.'

'All you did was to explain about the farm, and the land, and the golf course, and you put it very well, and I appreciated it very much.'

'You remember that, Hannah. Did you think that I ought to have said more than I did about my feelings?'

'No.'

'You resented that, perhaps.'

'No, not at all.'

'I was afraid you might not have done.'

They had to pause for a moment while a customer from another table came to borrow their bowl of sugar. The slight sense of loss and resentment which this caused,

in spite of Carroll's courteous 'Certainly', drew them together a little, and yet they could hardly be thought of as antagonists.

'But even if I said no more than that, did you truly believe that it was all the same to me one way or the other?'

'What else could I think, when you put the map and those other bits of paper back in that case of yours straight away?'

'They represented all the prospects I had at the time. I'm not likely to improve on them.'

'But you put them straight back and never blinked an eyelid.'

'I might have done, perhaps, if I'd been acting,' he said. 'I suppose then I should have been taught how to do it.'

Hannah felt the irritation of anybody who tells a lie for friendship's sake at being forced into the position in the first place. Of course she knew, and had very well known at the time, what it had been like for him to be turned down. And if in the long years to come, because he wasn't much over thirty, he was going to feel as much as this and be as little able to manage as he was now, what help would there be for him? From the desolation of such clarity, let us pray to be delivered.

'It's more than that, Pierce. I'd just as soon tell you about it now. I don't know why I'm making such a

business about it anyway. It's just that I'm becoming fond of someone else. No that's not true either. I *have* become fond of someone else.'

'You mean this actor you met recently, this man Lewis?'

'Yes, do you remember him?'

'Certainly I do. You introduced him to me outside the Nonesuch Theatre. Later I had an opportunity to see his performance on the opening night. Although I'm no judge of acting he seemed to me excellent. Is he a Roman Catholic?'

'Pierce, I've got no idea.'

'If he is, it will be a relief to your family.'

There it was again, how could you ever explain anything to him when he had all these ideas, they were as old-fashioned as Dick's hatband.

'I daresay my family won't ever meet him, they're not fond of the theatre as you know. It isn't a question of marrying him. He just comes round to my place or sometimes we go out after the show to have a drink or a plateful of ravioli or something.'

She felt this description as particularly false. Carroll tried to enter into its spirit.

'Ravioli now, am I right in thinking those are the ones in the shape of small pillows?'

In spite of herself she was looking into the mirror behind him. It was made of pink glass. She saw the

reflexion of the back of his head and shoulders, where defeat first shows absolutely.

'He hasn't asked me to marry him, Pierce, and if he did I wouldn't.'

She intended this as some kind of consolation, but he only replied, 'You'll be giving up your job, I take it?'

'Why ever would I?' she cried, glad of the chance to be annoyed. 'I don't want him to support me.'

'Fortunately I'm not called upon to understand this man. But you mustn't worry that it might be awkward for us, I mean for you, to go on meeting every weekday, as we are at present. For me it would be a good deal more than awkward, and for that reason I shall be resigning my job, in any case.'

Hannah was appalled. 'But Pierce, where will you go?'

Where would he ever find another post? All his oddity and incompetence in his profession were laid bare without her ever having intended it. But Carroll was not offended.

'I'm not sure that I'm within my rights in giving in my notice so late in the term. But then, employment at the Temple School is hardly a matter of rights.'

She began to say that Freddie and the Bluebell wouldn't know what to do without him, but the falsehood choked her, and she repeated with feeling, but without tact.

'Please stay, Pierce, please don't go.'

'Are you mad, Hannah?' he asked.

She was silenced. And why did she want him to stay anyway, to be hurt and hurt again, and have to talk about it in a place like Lyons.

It was nearly a quarter to seven and now they were being menaced by the table-wipers, who suggested taking their cups away with the terribly appropriate words *are you finished?* But both of them were skilled in the art of keeping a statutory amount of cold tea in their cups, which maintained the right to occupancy of the table.

Hannah, however, began to draw on a pair of knitted woollen gloves, with which the nuns still kept her in plentiful supply. She had one of them on, one off, when he took her hands between his, the only permitted lover's gesture in Lyons; she could feel the naked pressure on her left hand only.

'Hannah, I want to thank you from the bottom of my heart. I've noticed that over here in London a great deal of thanking and apologising goes on — in my opinion, far in excess of its object. Even you are beginning to surprise me a little in this respect Hannah. Surely we were neither of us like that before we came over here. People say "I'm sorry, but could you tell me the way to the Underground", what are they sorry for in God's name, and they'll thank you for nothing at all, they'll come through the revolving door, let's say in one of these large shops, those glass doors I mean, and come out the other side saying thankyou, thankyou very much — thankyou

to a piece of glass, I ask you. I'm not condemning it, it's a nervous habit. But I prefer myself not to thank anyone without a reason.'

'I don't know what you're thanking me for now, Pierce, honest I don't. After all . . .'

'May I explain?'

The table-wiper hovered, but deeply intent on each other as they were, both of them noticed at once and picked up their teaspoons so that they could not be dispossessed. For this purpose, Carroll reluctantly had to let go her two hands.

'I believe just now you were thinking of saying that after all there were tens of thousands of girls like you both at home and over here, and that before I knew where I was I'd find another one who would suit me better. I think you might have been going to say that because it's the kind of thing women say in these tea-places, or indeed, to judge from my sisters, at any time. You would have meant to spare my feelings, I expect, and I should have given the only possible answer, and then I should have added that it was really an impertinence for me to have planned what I did or dreamed what I did because if you should ever want to marry you must have the choice of any and every fellow with two eyes in his head.'

Hannah repeated that she was not getting married, but without hope of his paying any attention.

'You want me to come to the point. Well, when you

introduced me to this man Lewis, indeed, earlier than that, when you began to talk about him incessantly, I became jealous. I spoke to you once about jealousy as being my besetting sin, but I may be mistaken about that, because the sensation was quite new to me. Seasickness is the same, you get no preparation for it. I would compare jealousy to a violent attack of seasickness with no hope of the crossing ever coming to an end. It didn't come to an end when I passed the night with you in your flat. It didn't come to an end when I confronted you with those pieces of paper you were talking of just now, and realised what a ludicrous miscalculation I had made.

'But since that time I've given thought to the matter, or perhaps it would be more accurate to say I've thought about very little else, and I don't exactly know when it was that I came to see the whole situation rather differently. May I go back to what I said a few moments ago, that it's obvious you must have the choice of any man you may chance to meet, provided he's sane and has two eyes in his head. You remember my saying that?'

'I think so.'

'Well, that's the point, that's why my whole view has changed, and dearest Hannah, that's why I want to thank you. You don't want me and you never did and never will. But you've taken somebody who's not at all young — I could give him quite a few years, I think — not very successful, or at all events he's still

not playing the principal parts after all this time, not in good condition, not very much to say for himself, and above all, Hannah, nothing much to look at. It's a wonderful consolation to me that you didn't want a smart fellow, or a good-looking one that would do you credit in company. You asked me what I had to thank you for, and now I think I've made you see it. Even if you didn't turn to me, and I'm well aware that was too much to hope for, at least you turned to someone who resembled myself.'

Hannah had never let herself realise until this moment how near she was to loving Boney Lewis. The shock of indignation at hearing him described as an ageing failure, a poor thing like poor Pierce, beat up in her so warmly from the depths that she felt half blind. And then it was poor Pierce himself sitting opposite her and saying it. That was a test of human kindness harder than she had ever expected to face. Compassion had almost disappeared, she was left with nothing but duty, the duty not to tell him what she thought of him. Carroll, however, unaware, pursued his comparison as though nothing else mattered but to make it completely accurate.

'I can only hope that he also resembles me, in so far as that's possible, in his love for you, Hannah. I expect he can't imagine living without you, am I right?'

'I'm afraid they're closing now, Pierce. They'll be wanting to take our cups away.'

He overlooked her cowardice.

'I'm sure I must be right there.'

She helped him to retrieve his case and they threaded their way out, to part in the cold street. At the corner she gave him a hug and kiss, as one does to a cousin, or to the inconsolable. Perhaps the whole thing would turn out in the end to have been a help to him and next time he wouldn't make such a mess of it. But unfortunately, as she knew, real life is not susceptible to rehearsals.

'You must keep your spirits up,' she said.

'Ah, Hannah, you can't accuse me of that.'

Gleaming, *empressé*, and elaborately polite, Blatt appeared as Freddie's escort with a proper recognition of the strange occasion. He arrived on the dot. Either the politeness, or a sudden failure of nerve and dread of the coming confrontation, led him to offer Miss Blewett a lift, if she was going their way, in the taxi.

Well, the taxi would mean a few hundred yards off her journey, and she would get a closer view of the impressive pair between whom, against all the odds, she had now begun to dream of a Something. She locked and bolted the back door. Before doing so she remembered to look out into the yard, but could see nothing beyond some dark masses piled up, and the snow falling.

* * *

At the Ristorante Impruneta, it was not any failure in himself that Blatt detected. Indeed he didn't allow for failure, having braced himself to challenge Freddie at last on every outstanding point between them. Apart from anything else, Stewart, so he'd been told, was due back from Zurich, and he wasn't going to face Stewart empty-handed, with nothing settled. It wasn't the outing itself, unwieldy though that might be, that told against him, nor the anxiety of the arrival and the business of extracting her from these musty old ceremonial robes she'd seen fit to put on. This in fact was undertaken by a waiter, Freddie not appearing much less in sheer volume when her gown was taken away and hung up. No, it was none of these things that undermined, before the evening could properly be said to have started, the authority of Blatt as host. It was the entirely incalculable fact that the proprietor, his rarely-seen wife, his head waiter and all the subsidiaries and minor employees of the Impruneta came from one insignificant village south of Florence, Ognissanti a Fontesecca, and that Freddie, again for no given reason, was able to speak to them, not merely in Italian, but in the dialect of their unpicturesque hillside. In consequence, hearing the thickened consonants of their terreno, the staff emerged from behind the curtains and archways and gathered, before he had even thought about giving his order, round Blatt's table. They stood there, without apology, to hear the words of the elderly Signora. And when she had enthralled them

long enough, Freddie dismissed them with a flash of her spectacles.

The Impruneta was convivial, cosy and expensive, not really a place where people went – particularly on a Friday evening – to see and be seen, but it was not discreet either, and from the beginning to the end of dinner none of the other diners did much except look at Freddie or make half-hearted attempts not to do so. The atmosphere of her office, half throne-room, half lair, was transposed, apparently without difficulty, to these new surroundings. But here she occupied an entire corner, commanding her territory, a hugely moulting royal raven sprinkled with gems, while her large gestures caused a myriad lights to flash on the Lady Macbeth costume. In the earliest horror films, where the sea tended to give up its dead and mummy cases opened wide to show their inmates, there would have been a place for such a dress. Soon, also, the warmth of the Impruneta drew out of the ancient frock the odour of mothballs, and of time and disuse itself.

Blatt knew that all experience is an investment. He hadn't forgotten what a fool he had been made to look on the subject of Mission Street and the old East End, and he restrained himself now from asking Freddie at what point in her life she had learned the dialect of a Tuscan village. The trick was to recover the advantage he'd lost already.

'You ought to go out like this more often, Miss Wentworth,' he said.

'A very unwise suggestion.'

Blatt understood her. An evening out, for Freddie, could only be the celebration of a coming disturbance, or even a change. But that was all to the good.

In the voice of the gladiator about to enter the arena he ordered a dinner for two. From eating and drinking, he knew, not much persuasive effect could be hoped. They didn't interest her enough. Long before her final consent had been gained he had tried to find out about her preferences from Miss Blewett, who couldn't get much farther than Ovaltine. 'A glass of wine sometimes, of course. We have one for the Old Vic anniversary, and we had real cocktails, with cherries in them, when the Master came, but you won't find her indulging.' Freddie was not indulging now, and nor was he. They had come out to enjoy themselves, yes, but as contestants, not as revellers. Their confrontation, at one end of the room, was a kind of public performance in itself. Only when the coffee came did the audience look away. Well off, or they wouldn't have come to the Impruneta, they were keenly sensitive to the change of intonation between two diners which announces the discussion of money. The grand comedy, though still dramatic, had become a business meeting. Freddie turned now, in all her majestic slyness, completely towards Blatt.

'Tell them to take away this coffee, dear.'

Who gives the orders here, Blatt fretted to himself.

How would she like it if I left her to pay the bill? 'Don't you care for coffee?' he asked.

'It makes me sleepy.'

She folded her massive arms, trailing the long black fringes of her sleeves among the débris.

'There are going to be great changes at the Temple.'

His heart leaped. 'Am I the first to get notice?'

'Change, but not difference. As long as I stay there, the place will be identical. It's only what I have decided to do that will change.'

'I don't get you. That's what I've been putting to you for the last two months, and I think you spoke to me about a brother of yours that said the same or something like it. Do you mean you've come to agree with me?'

If only she could have given him a word of approval. It wouldn't have cost her anything. It wouldn't cost her a penny simply to say that she agreed with him for once. He would have liked to prise it out of her with a cold chisel.

'You're giving up,' he said as calmly as he could. 'You're finding the work too much for you, is that what it is?'

'On the contrary, I am getting rather too much for the work.'

'But you're making a change. You said that. Do you mean that you admit you've been wrong?'

'I mean that I'm right now.'

I can remember you wallowing on the floor, Blatt thought, why did I ever pick you up? Why am I bound hand and foot to this monster, this old cow in fancy dress, so the only thing that gets me going is to know whether she'll take me into association and whether she'll let me waste my money on her or not? Why can't anyone in this place take their eyes off her? And what should I have been if I'd never met her? What is the nature of slavery?

'When I say I'm right now,' Freddie went on, 'you ought to guard yourself against thinking of me as a self-centred old woman. I don't rely entirely on what suits me at the moment. There's the Word, dear. I'm fortunate, you know, that it comes so often just when I need it.'

He was suffused with fury. Now he was going to have this Word stuck on him, and after all what was it but the old Variety routine the comics used to do down at Brady's Club, several of them did it, Max Miller used to do it, there was this young chap, getting married and he didn't know what was what, see, lady, and as they were in the hotel going upstairs to bed there was this notice on the wall, see, lady – and he read the words, see, lady – 'It was something that someone said to me not very long ago, dear, but who it was has quite gone from me. Still, a benefit is more important than its source. Who was it who wrote that?'

'I don't know. It sounds like a member of the Liberal party.'

'The Word that came to me was, It's a great mistake to live with past victories. It's been with me before, that particular Word, but it's even more helpful now. You see, it has confirmed that when I put an end to that passing idea of a National Stage School, I was also bringing to an end what might be called the first period of Freddie's.'

She had been running it, so far, for forty years. Blatt wondered if he might offer her a cigar.

'You're the first person to whom I've told this, dear, but I've decided that I've done enough for Shakespeare. In the future he must do without my help.'

'Who's going to break that to him, lady?'

Freddie smiled indulgently.

'I've done everything I can for him, dear. He doesn't need me any more. There's going to be a complete trans-formation at the Temple School. As from next term I shall offer no training at all in Shakespeare or Peter Pan or the classic drama, no ballet, nothing for the movies because in the end they always want amateurs for the children's parts, my whole fluence, my whole resources, are going into the one thing – training for TV commercials.'

So the brick wall against which he had battered had come down without his even knowing it, but, as it seemed, in the wrong direction, felling him to his knees,

so that he gasped from the dust and rubble: 'You've run out of money. All the rest is gas. You're short of assets. That's why you're doing this. What does Unwin say?'

'Whatever could it have to do with Unwin? I haven't consulted him. If you want to know where he is, he's taking out Hilary Blewett, no doubt at the smallest possible expense he can contrive, to try and find out what it is I'm going to talk to you about. She won't know. But she'll enjoy herself — she has a great capacity for that. He never seems to realise that he's of no importance at all, except to tell me how much I'm in debt. The changes in Freddie's aren't a matter of money. I've done without money for far too long to start caring about it now.'

Blatt knew this was true. But, a cheated man, he realised also, with a bitter sense of loss, that the scorn of worldly things which had fascinated him against his will, and for so long, was itself an illusion. Freddie cared neither for art nor tradition nor for the theatre nor even for her children. She loved only power, indeed she loved Freddie's.

'Lilian used to pray a good deal,' he heard her saying. 'But she told me she didn't mind whether God saw through her prayers or not, as long as she got good houses at the Vic. It's my duty, you know, to take my school where the power is.'

'You don't know anything about TV,' Blatt shouted.

'I do know something.'

'That's not possible. Always you've had to ask me what it was all about, and you've never listened. You never see it. You've never even watched it.'

'I watched it in the hospital,' Freddie replied. 'It was turned on in the ward at midday and it went on without a break until close-down.'

'And that was enough?'

'It was quite enough, dear.'

'It got you,' he pressed her.

'I saw how it got other people, even if they were 89, 93, or 97. Let us say my eyes were opened.'

'After forty years.'

'Opened to the future, dear. There mustn't be a future without Freddie's.'

She had waved away reason and experience and honest offers of help and refused even to read through her own accounts, now after a couple of days' viewing in the company of the mindless and toothless, plus some slogan she'd picked up, she was turning her back on all she once stood for. She hadn't come to her senses. They were further away than ever. Something was slipping out of control. 'What about the parents?' he asked. 'Have you thought of them?'

'They trust me. I shan't persuade them. I shall just tell them what I'm going to do. As to my staff, well, Hannah Graves will go, I suppose, quite a nice girl, a

pity to lose her, and Carroll of course will stay. Where would he ever get another post?'

'And the kids? Aren't some of them supposed to be the hope of England? What about the little one that got pissed?'

Freddie hesitated, if only for a moment. 'You mean Jonathan Kemp. He always seems quite self-sufficient.'

'I did the wrong thing that day.'

'Did you? But you know I don't know why you're becoming so red in the face, dear, or why you're taking all this so hard. Have you forgotten why you took me out to dinner in the first place? Surely it was to flatter me into coming into some sort of business arrangement. I haven't decided yet whether to let you lend me any money or not. But, as you pointed out a few minutes ago, what I'm doing is exactly what you've been asking me to do for what seems rather a long time.'

'I'm not pretending anything, if that's what you mean.'

'Pretence would be wasteful. I know your point of view, I can hardly help it. I know exactly what you want.'

'But you don't know,' he cried in desperation. 'For eight days now I've been trying to say to you what I'm saying now. You thought, didn't you, that I wasn't educated up to Shakespeare, I was thick, I was the funny man who made you all feel good by being so thick. Well, listen to me and don't give me any more until I tell you

how it is with me now. In a sense telling you this was going to be my happy hour, Miss Wentworth, I thought that anyway. A week ago I went down to the theatre to see *King John*, no seats they made out but a friend of mine fixed it, it's one of his sidelines, and at first I thought, this is slow, it's the slowest thing that was ever inflicted on me, but when the scene came in the prison camp, where Stewart's boy has to stand up to the torturers, I sat there with tears running down my face so that I had to turn to the right and the left of me and ask them to excuse me for the tears. Before this, I told them, I cried only at the movies. I looked forward to this evening with you, Miss Wentworth, because I thought it would be a memorable moment when I told you that I wanted to invest in Shakespeare. So do me the favour to tell me what you think it feels like, now that you've trodden Shakespeare under and scraped him up and thrown him back in my face. You'll say to me, well, that was one scene from one act of only one of his plays, and there are others. But what more could everything that he ever wrote do for me?'

Now, surely, even if there was to be no other satisfaction, at least he had surprised her. But Freddie was silent only for a few moments, while her lips moved with a suggestion of chewing, as if she was a connoisseur of heartfelt words.

'You say that it was Mattie Stewart's performance that really moved you?'

'Yes, yes.'

'You liked him in the part? You thought he did it well?'

'I wanted to make it clear to you that I'm prepared to invest up to the limit, yes and a bit beyond, in a place that can train a child like that. Now you can tell me that I've got no sense.'

'I won't tell you that,' said Freddie,' 'but I'll tell you that you have no taste. You don't know bad acting when you see it.'

By this time Jonathan had been locked out of the Temple School for about an hour, but he had reckoned with this and at first it did not particularly disturb him. He had intended, if he got too cold, to go inside and scout round for a packet of crisps and to find somewhere to sleep in Costumes. There were plenty of drapes and blankets there. That wouldn't do now. Still, he had other resources. Although it would take a certain amount of nerve, there was nothing to stop him jumping down on the street side and getting out that way. The drop was a good bit longer, though, than the one he was doing at present, down into the middle of the yard.

His object was to get so used to the Jump that he could do it without thinking, and exactly the same way every time. The crates he had got hold of from the Garden were rotten, as indeed he'd noticed when he took them,

but by standing on the outside slats and exerting very little pressure he could manage the top of the wall quite easily. In the morning there would be someone to come and watch, and tell him whether he was right or not. Meanwhile he went on climbing and jumping, again and again and again into the darkness.

———